Sandro Bocola

Timelines –
The Art of Modernism
1870–2000

TASCHEN

KÖLN LONDON MADRID NEW YORK PARIS TOKYO

Front cover from top left to bottom right:

Claude Monet: *La Grenouillère*, 1869 (fig. 49)
Henri Rousseau: *Myself, Portrait and Landscape*, 1890 (fig. 1008)
Fernand Léger: *The Mechanic*, 1920 (fig. 327)
Jasper Johns: *Flag*, 1954/55 (fig. 538)
Claes Oldenburg: *Blue Shirt, Striped Tie*, 1961 (fig. 561)
Andy Warhol: *Twenty-Five Colored Marilyns*, 1962 (fig. 569)
Jeff Koons: *Pink Panther*, 1988 (fig. 845)

Paul Cézanne: *Cabin at Jourdan*, 1906 (fig. 110)
Pablo Picasso: *Reservoir at Horta de Ebro*, 1909 (fig. 128)
Piet Mondrian: *Rhythm of Black Lines*, 1935–1942 (fig. 257)
Josef Albers: *Structural Constellation F – 14*, 1954 (fig. 655)
Max Bill: *White From Complementary Colors*, 1959 (fig. 664)
Ellsworth Kelly: *Yellow Orange*, 1968 (fig. 705)
Karl Gerstner: *Color Fractal 6.06*, 1995 (fig. 914)

Vincent van Gogh: *Bouquet of Sunflowers*, 1888 (fig. 84)
Wassily Kandinsky: *Improvisation 26 (Rudders)*, 1912 (fig. 170)
Henri Matisse: *Icarus*, 1943 (fig. 291)
Jackson Pollock: *Number 33*, 1949 (fig. 453)
Kenneth Noland: *Bloom*, 1960 (fig. 493)
Mark Rothko: *Untitled*, 1968 (fig. 520)
Brice Marden: *Daoist Conclusion*, 1991–1995 (fig. 818)

Edvard Munch: *The Scream*, 1893 (fig. 118)
Giorgio de Chirico: *Mystery and Melancholy of a Street*, 1914 (fig. 314)
Marcel Duchamp: *Bottlerack (Bottle Dryer)*, 1914 (fig. 320)
René Magritte: *The False Mirror*, 1928 (fig. 399)
Francis Bacon: *Lying Figure No. 3*, 1959 (fig. 739)
Bruce Nauman: *Untitled*, 1967 (fig. 787)
Walter de Maria: *Lightning Field*, 1977 (fig. 778)

© 2001 TASCHEN GmbH
Hohenzollernring 53, D–50672 Köln
www.taschen.com

Concept, text, choice of pictures
and graphic design: Sandro Bocola, Zurich
Editorial coordination: Juliane Steinbrecher, Cologne
Translated from the German: Nicholas Levis, Berlin
Typesetting: Daniela Kumor, Cologne
Digital realization of the layout: Justo Barragán, Romanshorn
Photo montage, index of illustrations
and bibliography: Eugen Eberhard, Zurich
Production: Erhard Schulz, Cologne

Printed in Italy
ISBN 3-8228-1358-3

Contents

Acknowledgments

Several people have contributed towards the realization of this book.
Eugen Eberhard managed and processed the pictorial archive, put together the illustrated pages, and edited the bibliography and index of illustrations. He gave me many opportunities to test my thinking and evaluate the ongoing work in a series of fruitful discussions. Justo Barragán helped design the layout and book cover and displayed his competence and sensitivity in the digital execution of the design. Bernhard Bürgi, Director of the Public Art Collection of Basel, advised me in selecting pictures for the last chapter and in the process familiarized me with the works of artists I had hardly known. Fritz Billeter read the German manuscript and provided a number of valuable suggestions and improvements. I am thankful to each of them for their commitment, their readiness to help and their interest. Special thanks are due to Jürgen Tesch, director of Prestel Verlag in Munich and New York, for his permission to use passages in the following from my book *The Art of Modernism. Art, Culture and Society from Goya to the Present Day* (transl. by Catherine Schelbert and Nicholas Levis).
My sincerest thanks go to Benedikt Taschen for having courageously agreed to publish this unusual illustrated volume, and to Juliane Steinbrecher and Erhard Schulz for their excellent editorial work on the book.
Finally, I thank my companion Yvonne Wilen, who stood by me with affection and confidence throughout the course of this work.

Sandro Bocola

Introduction

This book endeavors to present the development of Modernist art, from its Impressionist origins to the pluralist art scene of the present, as a coherent, unified and meaningful process. In my earlier textbook on *The Art of Modernism,* which was published by Prestel Verlag in 1999,[1] I pursued a detailed discussion of this development over 650 pages, analyzing it in the terms of art history, social history, and psychoanalysis. The point of the present volume is not so much to describe or analyze, but to actually show the development in the form of a synchronoptic survey using pictorial reproductions arranged by chronology and style.

Underlying this overview are two postulates that I shall now briefly summarize. The first concerns the paradigm of Modernism, meaning its guiding idea and the course of its cultural development. The second relates to the four underlying artistic and ideational attitudes that drove this development forward.[2]

The Paradigm of Modernism and the Cyclical Course of Artistic Development

I view Modernism as an independent cultural age, comparable to Graeco-Roman antiquity (500 BCE–400 CE), the European Middle Ages (400–1300 CE) and the early Modern Era (1400–1900). A look at the start and end points of these epochs reveals that they diminish successively in length. Modernism, the beginnings of which I date around 1870,[3] already seems to be drawing to a close, and is hardly likely to survive the 21st century. This dwindling life expectancy of historical epochs is the consequence of a steady acceleration in cultural development. But the fact that Modernism is of relatively brief duration does not lessen its status as a cultural age.

We define a cultural age as the longest period of time determined by the influence and consequences of a given event, person or idea. A cultural age is thus delimited both temporally and geographically. Every cultural age is governed by an overarching, idealized conception that not only supplies the foundation for the social fabric connecting people in a given society, but also coincides with a "religious" vision that bridges the gulf between humans and the world and joins them within a larger whole.

Greek and Roman antiquity were shaped by the awakening of individual consciousness and rested on the idea of the indivisible, the individual, the atom; just as the Christian Middle Ages were based on faith in eternity, in a son of God who became human, and in life after death. The Modern Era was exemplified in the idea of genius, of the almighty God-man, the white man who achieves domination over nature and the world.

[1] Sandro Bocola, *The Art of Modernism. Art, Culture and Society from Goya to the Present Day,* transl. Catherine Schelbert and Nicholas Levis (Munich/New York, 1999).

[2] These two postulates, and a third thesis based in psychoanalysis, form the theoretical substructure of my earlier book (Bocola, 1999) and are discussed at length therein, especially in the chapter "Main Theses", pp. 18–32.

[3] In terms of art history: during this time, a group of young artists in Paris around the painter Edouard Manet founded the Société Anonyme des Artistes, Peintres, Sculpteurs et Graveurs, which gave birth to Impressionism. In terms of social history: in Paris, besieged during the winter of 1870/71, the Paris Commune marked the beginning of a new political epoch. See Haffner, 1987, p. 61.

This last paradigm, with its separation of body from soul and of man from the world, defined the spirit of the early Modern Era from the Renaissance to the Enlightenment. At the end of the 19th century it gave way, with the beginnings of Modernism, to the idea of a scientifically confirmable unity of all being.

The holistic vision underlying Modernism is no longer based in a belief that humans and the world share a common divine origin, but arises from new insights into the predictable functioning of reality and the mutual interdependence of anonymous anorganic, organic, psychic and intellectual forces. These forces are understood as different manifestations of a finally incomprehensible unity, the parts of which are so closely interconnected that it is, in effect, indivisible. Science, the paradigm of Modernism, strips humans of their divine attributes, but at the same time sees them in a completely new way, as part of a larger whole, integrating humankind into the natural order as a link in the long chain of evolution.

The paradigm of each age defines the self-image and the worldview of those who live in it. It invests individual and collective ambitions with meaning, measure and orientation, forms the spiritual basis of a given culture, defines individual and social life in many ways, and finds representative expression in art. In the process, the paradigm itself is subject to change as a consequence of artistic endeavor, while these endeavors (and everyday life) are in turn affected by independent changes of the paradigm. The development of art is propelled by this interplay between specific worldviews and self-images, and their formal manifestation in works of art.

Because it mirrors the birth, growth, decline and death of its guiding idea, the artistic development of a cultural age is usefully compared to the course of a human life. A new paradigm germinates in the spiritual heritage of the preceding age, even as that draws to a close. The paradigm progresses through childhood and youth (its archaic epoch) and reaches the classical phase of its development on coming of age; as its artistic, aesthetic manifestations acquire a clear, distinctive, and unmistakable shape, the new idea finds its own language and conventions. Subsequent generations test the viability of these conventions, adapt them to their own expressive needs, and apply and modify them in a host of different ways. Finally, the expressive and formal potential of the once unknown paradigm is fully explored and exhausted. Despite repeated attempts at regeneration, it gradually and inevitably loses credibility and appeal, until it is finally supplanted by a new vision, a new paradigm. Thus begins the next cycle, a new age.[4]

The artistic development of Modernism ran through an analogous series of stages, and we can therefore divide our history of it into periods.

[4] Every age adopts essential aspects of the ideas that preceded it but subjects them to fundamental changes.

The Four Artistic Attitudes

Art is a way by which the mind reflects on reality, not unlike science or religion; but it takes place on an aesthetic level of experience, where the artist and the observer are confronted with four existential questions:

— What is real? What is the value of preserving a proof of our existence?
— How does the real fit together? What order combines everything real into a single, connected whole?
— What makes up our inner reality? How is it connected to the outer reality, to nature, to the universe?
— What is above or behind reality? What gives it meaning?

These questions are approached by four basic ideational attitudes or objectives, which I describe here as the empirical-realistic, the visual-structural, the expressive-romantic and the idealist-symbolist.

The empirical or **realistic** approach is geared toward sensually perceptible reality, which it seeks to recreate as an objective image so as to grasp it intellectually. (Examples: Impressionism, emblematic Realism, Neue Sachlichkeit, Pop Art, Nouveau Réalisme.)

The visual or **structural** approach is based on aesthetic principles of order, by which individual appearances relate to one another and can be combined to create a pictorial whole. It seeks to master reality by grasping it as an aesthetic order. (Examples: Pointillism, Cézanne, Cubism, De Stijl, Constructivism, Minimal Art.)

The expressive or **romantic** approach has to do with emotional, subjective introspection. It seeks to merge with reality by experiencing it as an expression of one's own emotion. (Examples: Gauguin, Van Gogh, the Fauves, German Expressionism, Kandinsky, emblematic Surrealism, Abstract Expressionism.)

The idealist or **symbolist** approach contemplates the riddle of human existence and seeks to transcend reality by lending meaning to it through a given interpretation. (Examples: Ensor, Munch, De Chirico, figurative Surrealism, Arte Povera, Land Art.)

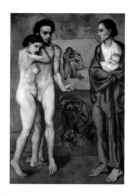

123. Pablo Picasso: *Life*, 1903. Oil on canvas, 196.5 x 128.5 cm

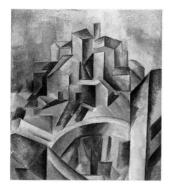

128. Pablo Picasso: *Reservoir at Horta de Ebro*, 1909. Oil on canvas, 60.3 x 50.1 cm

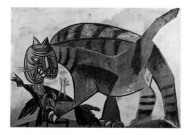

422. Pablo Picasso: *Cat and Bird*, 1939. Oil on canvas, 97.1 x 130.1 cm

Only in theory can these approaches be isolated from one another. In actual artistic practice, they are never found in pure form but in complex combinations that find expression in, and determine the character of, different works and movements. All great works of art include elements of all four attitudes – but one of the four always assumes the predominant role.

We might easily find realist, romantic and symbolist elements expressed in a painting by Cézanne – yet all will be subject to the primacy of the structural that marks his work. In a Van Gogh, by contrast, realist, structural and symbolist tendencies might be combined within a primacy of the romantic.

Having chosen a primary attitude, artists normally remain true to it, although some do change course in the process of their individual development. Picasso, for example, shifted from the idealist-symbolist attitude of his Blue Period (fig. **123**) to the visual-structural attitude of Cubism, which he developed together with Braque (fig. **128**). He then returned to symbolism in his later surrealist portraits and figures (fig. **422**). Similar conversions may be observed with Cézanne, Klee, Miró, Duchamp, Giacometti, Johns, and many other artists. Our ordering principle thus does not refer to specific artists, but to the artistic attitudes expressed in their works.

In rare cases, two of the basic attitudes can be expressed so equally in a work that it is difficult to determine which is predominant. Despite the occasional borderline case, what matters is that the idea of the four basic attitudes allows us to order the artistic development of Modernism meaningfully into four separate, parallel lines of development. The diagram below illustrates the ordering principles of my analysis as a set of coordinates:

		1800–1870	1870–1905	1905–1945	1945–1980	1980–2000
realistic	▷					
structural	▶					
romantic	▶					
symbolist	▶					

The horizontal rows in the diagram represent the four basic attitudes – more accurately, they document four lines of artistic development, each of which expresses the primacy of one of the four attitudes.

The columns mark the decisive, successive stages or periods within the overall development. Each phase finds its realistic, structural, romantic and symbolist expression. In their essence, the goals of the four basic attitudes remain constant. Each new articulation of those goals reflects the stylistic transformations to which their artistic expression has been subordinated in the course of previous development.

The method of synchronous visual documentation employed herein uses rows of small, chronologically ordered reproductions to portray artistic developments along four parallel lines. Each of the reproductions is labeled only with the name of the artist and the year in which the work was created. The titles, materials employed, and other information about each work can be found in the index of illustrations.

This simple model allows us to locate the work of an artist psychologically, stylistically and historically within the overall development of Modernism, and in meaningful relation to the works of other artists. The ordering principle may be seen in the table on the following two pages, which provides an overview of the contents and design of this book.

Each of the four basic attitudes has been assigned a color. Colored labels (lines and arrows) at the beginning of each series of pictures indicate the corresponding attitude.

The realistic attitude is in yellow.

The structural attitude is in green.

The romantic attitude is in red.

The symbolist attitude is in blue.

	1800 – 1870 The End of the Early Modern Era	**1870 – 1905** The Beginnings of Modernism	**1905 – 1945** The Aesthetics of the Universal
realistic ▶	**Realism** – Constable, Corot	**Impressionism** – Manet, Degas, Monet	
	pages 17–28	*pages 29–42*	
structural ▶	**Neoclassicism** – David, Ingres	**Postimpressionism** – Seurat, Cézanne	**The Way to Nonfigurative Art** **1905–1925** **The First Developmental Stage** – From Cubism to geometric non-figuration
	pages 17–28	*pages 29–42*	*pages 47–55*
romantic ▶	**Romanticism** – Goya, Géricault, Delacroix, Turner	**Postimpressionism** – Van Gogh, Gauguin	**The Way to Nonfigurative Art** **1905–1925** **The First Developmental Stage** – From Fauvism to Painterly Abstraction
	pages 17–28	*pages 29–42*	*pages 47–55*
symbolist ▶	**Symbolism** – Blake, Friedrich, Carus, Runge	**Expressionism** – Munch, Ensor	
	pages 17–28	*pages 29–42*	

I have organized the artistic development of Modernism into five periods or developmental phases, each of which is documented in its own chapter. Each chapter is introduced by a brief review of the sociohistorical background and the ideal and stylistic properties of the presented works. Clearly, these short texts cannot do justice to the complex issues involved. For a complete treatment of these developmental phases, their preconditions in the history of art and social history and their psychological prerequisites, I again point the reader to my earlier textbook, *The Art of Modernism. Art, Culture and Society from Goya to the Present Day,* on which the present volume is based, and which follows much the same organizational scheme.[5]

This volume is mainly concerned with works of painting and object art. By no means does it raise claims to comprehensiveness, not even within its chosen genres. In gaining an overview of the grand lines of Modernism's development, I necessarily limit myself to its most pathbreaking and influential artists, and even they are only represented here with works from their decisive years of creation.

A Note on Synchronoptic Presentation

In the course of the 20th century, each of the four basic attitudes has given rise to art of such volume and diversity that its development cannot be portrayed in a single row of pictures. Only for the years 1800 to 1905 can the developmental lines of all four attitudes be portrayed in parallel on the same page. For the period from 1905 to 1945, each of the four basic attitudes is documented using two rows of pictures; and from the period from 1945 to 2000, each basic attitude fills all four rows of the timeline. The latter chapters thus necessarily show simultaneous developmental phases one after the other.

See the examples on the facing page of the various layouts employed for the timelines in this book.

[5] A note at the beginning of each section will point to the corresponding pages in my earlier textbook (Bocola, 1999), in which each phase in the evolution of modernist art is discussed in detail.

Introduction

1) pages 24–27 and 36–41

All four basic attitudes are documented on the same timeline, with one row of pictures for each attitude.

Chapters:

1800–1870. The End of the Early Modern Era

1870–1905. The Beginnings of Modernism

2) pages 50–55, 64–69 and 74–83

This layout shows only two of the four attitudes, using two rows of pictures for each.

For example, the two-page spread to the right documents the structural and the romantic attitudes.

Chapters:

1905–1945. The Aesthetics of the Universal

The Way to Nonfigurative Art
1905–1925. The First Developmental Stage
1925–1945. The Second Developmental Stage

The Way to a New Figuration

3) pages 58–61

This layout shows two of the four attitudes, with one row of pictures each.

For example, the two-page spread to the right documents the structural and the romantic attitudes.

Chapter:

1912–1922. The Russian Avant-Garde

4) pages 92–99, 104–111, 114–119, 124–129 and 138–153

This layout shows only one of the four attitudes, using four rows of pictures for it alone.

The two-page spread to the right documents the symbolist attitude.

Chapters:

1945–1980. Triumph and Consummation

1980–2000. The End of Modernism

1800 – 1870
The End of the Early Modern Era

1800–1870. The End of the Early Modern Era

The art of Modernism did not arise suddenly from a void; it was in emergence long before the first exhibition of the Impressionists. To locate Modernism within context and view it in light of its intellectual and artistic foundations, I shall first sketch the social and political conditions and the development of art in the period which preceded Modernism, meaning the outgoing phase of the early Modern Era (1800–1870).[6]

With the exception of a few progressive minds, Europe at the end of the 18th century no longer possessed any unifying political or religious idea. Nevertheless, thanks to its achievements in science and technology, Europe was able to control all of the world's coasts and settle the weakly populated continent of America. We cannot go into the history of these colonial enterprises. Suffice to say that in 1775, the British Crown's total disregard of political and economic realities, its obstinacy and avarice led to the outbreak of the American War of Independence, which, with the Peace of Versailles in 1783, spelled the end of the British Empire in the Atlantic. As though a dam had been broken, events followed at a breakneck pace. In 1787 the Constitutional Convention of the United States passed the first modern democratic constitution.

In 1789 the French Revolution began, and in 1792 the Republic was proclaimed in France. In 1799 Napoleon became First Consul of the French Republic. He conquered nearly all of Europe from 1804 to 1812, and after his defeat at Waterloo in 1815 was forever banished to the island of St. Helena. In the years 1811 to 1821, the Spanish-Portuguese colonial empire came to an end with the independence of Venezuela, Paraguay, Argentina, Peru, Mexico, Brazil and Uruguay. In the space of a few decades, new inventions transformed all previous standards of distance, time, and human labor.

Everything had been set into motion, and this motion accelerated constantly. In the 19th century, the spirit of revolution became the defining constant of the political, economic, social and intellectual life of the Western world.

After the defeat and final banishing of Napoleon, the victorious powers convened at the famous Congress of Vienna and attempted as much as possible to reestablish the conditions that had obtained before the great storm. These efforts were doomed inevitably to fail. They succeeded in creating a new international balance of power, and in securing a peace of several decades for Europe, but the socio-historical effects of the Revolution could no longer be reversed. That was especially true of France, where it proved impossible to reintroduce the institutions and laws of the Ancien Régime. The privileges of the aristocracy had been swept away, the old administrative system replaced by a centralized, logical system that really worked, the old judicial system by a uniform system of courts and by laws that were codified and binding on all parts of the country.[7] In this way, the cultural

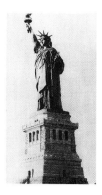

1001. Frédéric Auguste Bartholdi: *Statue of Liberty* in New York Harbor, 1886. copper, height 46 m

[6] The following pages correspond to the detailed treatment in Bocola, 1999, pp. 35–116.

[7] See Craig, 1974, p. 61.

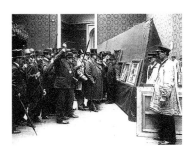

1002. The jury for painting votes on submissions to the Parisian Salon of 1903.

cycle of the early Modern Age entered its final phase; during the rest of the 19th century the political, economic, social, and aesthetic transition from Modernity to Modernism was completed, step by step.

Everyone sensed but no one understood the threatening reality of impending social and intellectual upheaval. The heroic consciousness of living in a time when all values are subjected to a radical reevaluation was not accompanied by a genuine understanding of the underlying historical development. That understanding remained unstructured, and exhausted itself in registering the emotional side effects: a generally heightened but undifferentiated collective euphoria was coupled with an amorphous and objectless attitude of anticipation – sometimes optimistic and looking to the future, sometimes wistfully retrospective. Being undefined, this consciousness eluded pictorial interpretation.

In Paris, London, and other European capitals, the royal academies that trained up-and-coming artists staged large annual exhibitions. In the course of time, these evolved into major social events that could make or break an artist. Known as salons, after the Parisian "Salon des peintres français," these gave art a new kind of public character. Until the French Revolution, participation in the salons was restricted to members of the academies. Napoleon extended the right to exhibit, at least insofar as all artists were allowed to submit their works to the salon; but in order to be exhibited, works still had to gain the approval of a rigorously academic jury appointed by the Institut National des Sciences et des Arts (fig. **1002**). In quantity, art production during the Second Empire surpassed all earlier epochs. At the annual exhibitions of the Salon from 1864, some four to six thousand paintings and sculptures were on view, attracting some 300,000 visitors each year. The artistic quality of the works on display was in no way commensurate with the immense popularity and financial success of this event; apart from a very few exceptions, the aesthetic and spiritual level had reached an all-time low.

By the second half of the 19th century, according as the art scene became more democratic and a free art market emerged, the former patrons of the arts were replaced by an aspiring bourgeois class of buyers with little aesthetic expertise. The new masters sought stimulation, amusement and entertainment. Art was supposed to be stirring, inspiring or frightening, to serve up melodrama or titillation, adventures without danger, heroic passions, moral convictions, models worthy of our admiration, patriotic virtues, and all manner of vicarious thrills. Most importantly, however, art was expected to authenticate the opinions and prejudices of the bourgeoisie and ward off the doubts and anxieties that threatened its self-image. Salon art under the French Second Empire replaced inner and outer reality with an illusion, wherein naturalist technique was employed to lend credibility to the subject matter. Purveying to an opportunistic and idealizing attitude,

much of the art of this time degenerated into kitsch (figs. 7, 20, 28, 31, **33**, 34, **41**, 47, 48).

41. Henri Gervex: *Rolla,* 1878. Oil on canvas, 173 x 220 cm

Significantly, the creative and genuinely innovative artists of this period rejected the illusionist Naturalism of the Salon painters. The rendering of nature with photographic precision cannot be reconciled with the free brushstroke of Delacroix, nor with the realistic approach of artists like Daumier, Courbet, or Manet, who attributed vital significance to the process of painting. A gap opened between the so-called "official" art oriented to the Academy tradition, and the progressive artists who espoused new ideals and discovered new themes for art and new ways of expression. Since they became the predecessors to Modernism, I devote the main part of the following analysis to them.

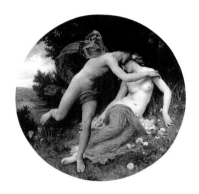

The defining experience shared by all of these artists was the onslaught of constantly accelerating change in all areas of life. This historic upheaval was perceived by contemporary society as both an opportunity and a threat; it was embraced and opposed. The differing ideational attitudes adopted by the artists of the time in dealing with their shared experience of historic upheaval mirror the four main directions that artistic developments in the 19th century took: Neoclassicism, Romanticism, Symbolism, and Realism. These correspond to the four basic attitudes that I have defined as the constants of artistic development in my analysis.

33. Adolphe William Bouguereau: *Flora and Zephyr,* 1875. Oil on canvas

The Structural Development

The striving for a coherent order found expression in the artistic current of classicism. The Neoclassicism of the 19th century represents the most obvious, if not the only attempt to cope with a changing present by recurring to the values and traditions of the past and the artistic canon of Antiquity (David, Ingres). The idealistic conservatism of this style, which reigned throughout Europe, provided a convenient overarching image of the enemy against which all progressive contemporary trends could unite in opposition. All progressive developments in 19th century art can be understood as rebellion against the absolutism and conservative maxims that found artistic expression in Neoclassical doctrine (fig. **9**).

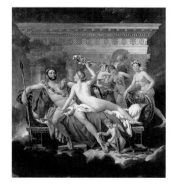

9. Jacques Louis David: *Mars Is Disarmed by Venus,* 1824. Oil on canvas, 318 x 270 cm

37. Eugène Delacroix: *The Abduction of Rebecca*, 1858. Oil on canvas, 105 x 81.5 cm

35. William Turner: *Dawn of Christianity (Flight into Egypt)*, 1841. Oil on canvas, diameter 78.5 cm

The Romantic Development

The Romantic movement was preoccupied with the inner world of emotion and fantasy. During the post-revolutionary Restoration, Romanticism became the organ of a younger generation whose idealistic expectations were disappointed by politics and reality. Its artists divided into two wings, one artistically progressive and extroverted, the other artistically conservative and introverted; they shared nothing other than a mutual glorification of emotionality.

The "extroverted" Romantics (Goya, Géricault, Delacroix, Turner) tended to show dramatic, turbulent subject matter using a dynamic, sensual mode of representation, in which the process of composition carries increasing weight as the vehicle of meaning. Painting dissolves the drawing, the brushstroke becomes pastose and dynamic, color acquires new meaning – a tendency that foreshadowed the great achievements of the early modernists (figs. 11, 13, **35**, 36, **37**, 39).

By contrast, the "introverted" Romantics remained true to the religious and political ideals and artistic canon of previous epochs. Because of their attitude of mind and their heavily symbolic subjects, in our analysis they are assigned to the symbolist line of development, as the forerunners to Symbolism proper.

The Symbolist Development

The symbolist attitude is represented in the first half of the 19th century by the introverted Romantics (Blake, Füssli, Friedrich, Runge, Carus), followed in England in the 1860s and 1870s by the Pre-Raphaelites (Rossetti, Burne-Jones, Millais, Morris, et al.). Their works manifest a longing for lost faith, for the lost meaning of life; in the final analysis, a desire for a new revelation. These artists were resolutely opposed to the materialist and positivist tendencies of their age and disdained the new world of machines and industry. They aspired to greater things, to higher art and spiritual values. They understood themselves as priests, proclaimed ascetic ideals, and searched for the mysteries of being. Their works are characterized by static, stationary subject matter and a literary, narrative form of representation. Drawing predominates, brushstroke is invisible, the palette is generally muted (fig. **20**).

This attitude of mind found its most pronounced expression in the second half of the 19th century in Symbolism, an art current that united musicians and poets as well as a great many painters and sculptors. The Symbolist painters (Moreau,

20. Carl Gustav Carus: *Memorial to Goethe,* 1832. Oil on canvas, 71.5 x 53.5 cm

Puvis de Chavannes, Böcklin, Klinger, von Stuck, Klimt, Redon, et al.) shared with the German and English Romantics a consciousness of standing at the end of a historic epoch, of facing the dissolution of a civilization. Their contradictory artistic oeuvre, which glorified either purity, nobility and solemn grandeur or else sin and sex, death and the devil (figs. 43, 45, **46**, 48) had as its common features a display of their own anxieties and escapist fantasies, reverence for old, tired and etiolated cultures like Hellenism and the late Roman period, world-weariness, and a longing for death.

46. Gustave Moreau: *The Chimera,* 1867. Oil on wood, 32 x 26 cm

The Realistic Development

Even as the movements mentioned above were glorifying Antiquity, personal emotion, improbity and spiritual grandeur, a development diametrically opposite to these currents led from Romantic landscape painting (Constable, Corot, Rousseau) to a complete abandonment of transcendentalism and the rediscovery of ordinary, visible reality (Courbet, Daumier, Manet, Degas) (see figs. 5, 21, 22, **23**, 26).

The artists of this current, which was called Realism, stopped attributing symbolic meaning to the subject of their work. Gustave Courbet, one of its most important exponents, defined his creed in the following, celebrated words: "*I hold that painting is essentially a concrete art and does not consist of anything but the representation of real and existing things. It is a completely physical language, using all visible objects as its words. An abstract object, one which is invisible or non-existent, does not belong to the realm of painting.*"[8] Only the work itself is idealized, not its subject. That could be anything, if only it is approached honestly. We encounter a similar attitude in the works of a group of painters who gather around Edouard Manet (figs. 25, 27), and in their Impressionism we see the origins of Modernism.

23. Honoré Daumier: *The Laundress,* 1863. Oil on wood, 49 x 33.5 cm

[8] Quoted in Gage, 1974, p. 39.

1800–1870. The End of the Early Modern Era

The realistic development

leads from Romantic landscape painting (Constable, Corot) to a complete abandonment of transcendentalism and the rediscovery of visible reality (Courbet, Manet, Degas).

realistic ▶

1. Valenciennes, ca. 1790

The structural development

with its striving for measure and balance, harkens back to the themes and artistic canon of Antiquity in the painting of Neoclassicism (David, Ingres).

structural ▶

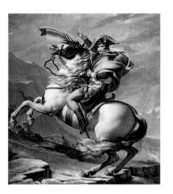

6. David, 1800

The romantic development

expresses an attitude that understands reality as a reflection of one's own emotionality. The extroverted Romantics (Géricault, Delacroix, Turner) tended to use a dynamic, sensual mode of representation, in which the process of composition carried increasing weight as the vehicle of meaning.

romantic ▶

11. Goya, 1798–1800

The symbolist development

is marked by static, stationary and heavily symbolic subjects, as seen in the art of the introverted Romantics (Friedrich, Carus and Runge). Their devotion to the spiritual culminates in the world-weariness and longing for death of the Pre-Raphaelites (Millais, Morris) and the artists of Symbolism (Moreau, Puvis de Chavannes, Böcklin).

symbolist ▶

16. Blake, 1795–1805

2. Benoist, 1800 4. Constable, 1824 5. Corot, 1830–1835

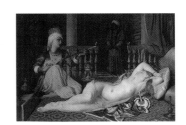

7. Gérard, 1807 8. Ingres, 1814 9. David, 1824 10. Ingres, 1839/40

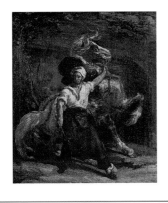

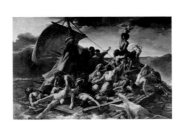

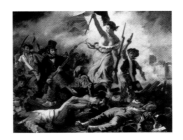

12. Géricault, 1814 13. Géricault, 1818 14. Delacroix, 1830 15. Turner, 1833

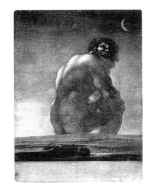

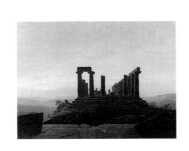

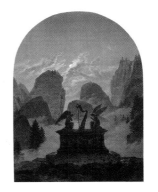

17. Runge, 1808 18. Goya, 1818 19. Friedrich, 1830 20. Carus, 1832

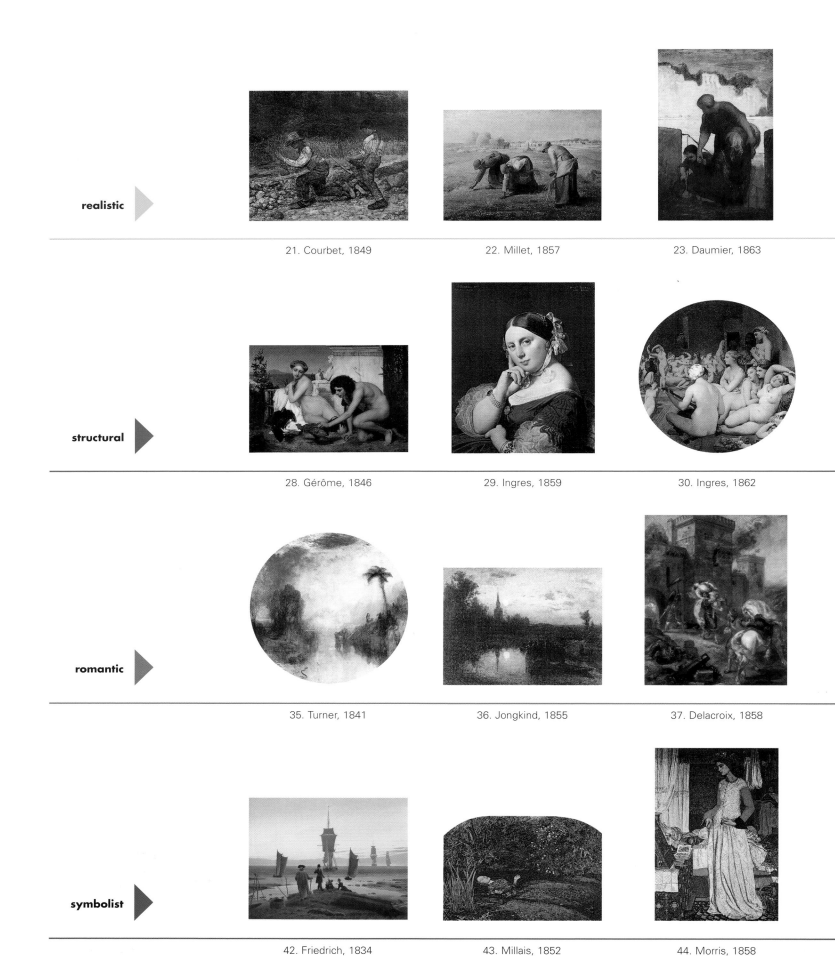

realistic

21. Courbet, 1849

22. Millet, 1857

23. Daumier, 1863

structural

28. Gérôme, 1846

29. Ingres, 1859

30. Ingres, 1862

romantic

35. Turner, 1841

36. Jongkind, 1855

37. Delacroix, 1858

symbolist

42. Friedrich, 1834

43. Millais, 1852

44. Morris, 1858

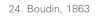

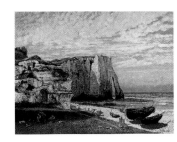

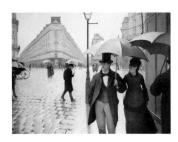

24. Boudin, 1863

25. Manet, 1869

26. Courbet, 1870

27. Caillebotte, 1877

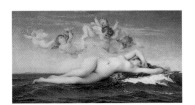

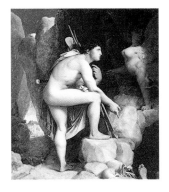

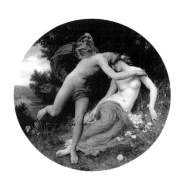

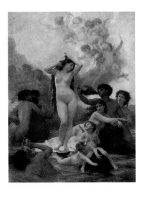

31. Cabanel, 1863

32. Ingres, 1864

33. Bouguereau, 1875

34. Bouguereau, 1879

38. Delacroix, 1862

39. Cézanne, 1867

41. Gervex, 1878

45. Moreau, 1864

46. Moreau, 1867

47. Puvis de Chavannes, 1872

48. Böcklin, 1880

Marie-Guillemine Benoist 1768–1826
William Blake 1757–1827
Arnold Böcklin 1827–1901
Eugène Boudin 1824–1898
William Adolphe Bouguereau 1825–1905
Alexandre Cabanel 1823–1889
Gustave Caillebotte 1848–1894
Carl Gustav Carus 1789–1869
Paul Cézanne 1839–1906
John Constable 1776–1837
Jean-Baptiste Camille Corot 1796–1875
Gustave Courbet 1819–1877
Honoré Daumier 1808–1879
Jacques Louis David 1748–1825
Eugène Delacroix 1798–1863
Caspar David Friedrich 1774–1840
François Pascal Simon Gérard 1770–1837
Théodore Géricault 1791–1824
Jean Léon Gérôme 1824–1904
Henri Gervex 1852–1929
Francisco de Goya 1746–1828
Jean Auguste Dominique Ingres 1780–1867
Johann Barthold Jongkind 1819–1891
Edouard Manet 1832–1883
John Everett Millais 1829–1896
Jean-François Millet 1814–1875
Gustave Moreau 1826–1898
William Morris 1834–1896
Pierre Puvis de Chavannes 1824–1898
Philipp Otto Runge 1777–1810
William Turner 1775–1851
Pierre de Valenciennes 1750–1819

1870–1905
The Beginnings of Modernism

1870–1905. The Beginnings of Modernism

In the second half of the 19th century, scientific and technological progress within the span of a few decades caused a fundamental transformation of European society.[9]

The educated strata of society were greatly influenced by new scientific theories, especially Charles Darwin's teachings on the origins of species and the natural selection of the strong and fit. These theories undermined the already weakened authority of the church and promoted an increasingly materialist attitude of mind and new concepts of the world and of the human being based in the natural sciences. But popular thinking remained indifferent to scientific developments – until a series of spectacular inventions began to transform the general conditions of life.

The introduction of railroads, steamships, automobiles and aircraft radically reduced accustomed travel times. New forms of steel processing allowed the making of gigantic ships and machines and facilitated the new building methods that caused international sensations in 1851 with the Crystal Palace in London, in 1870 with the Brooklyn Bridge in New York, and in 1889 with the Eiffel Tower, the symbol of the Universal Exposition in Paris.

The discovery and use of electricity, although incomprehensible to most people, opened up unsuspected possibilities. In the second half of the 19th century, a telegraph network was extended over the entire civilized world. News now spread almost instantly around the globe. Step by step, the telephone (1876), permanent street illumination by electric arc-lamp (1877), electric street cars (1881), the gramophone and the audio record (1887) revealed to the amazed citizens of the modern world the incredible potential of the new forms of energy.

Scientific and technological progress opened to collective consciousness perpetually new realms of the hitherto unknown and impossible, time and again invalidating generally accepted criteria.

The accelerated growth of cities had profound effects on the way people felt about their lives and conceived of themselves and of the world. The city created a completely new, artificial environment and the first mass media and new forms of social communication that encouraged the politicization and democratization of all areas of life.[10]

In the visual arts, the cultural upheaval that ushered in Modernism took form during the last decades of the 19th century. The decisive step of the great pioneers consisted in their radical renewal of pictorial techniques and the change in meaning these artists attributed to the artistic and creative process.

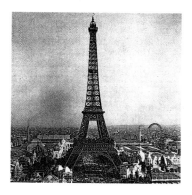

1003. Alexandre Gustave Eiffel: *The Eiffel Tower*, 1885–1889. Height 300 m

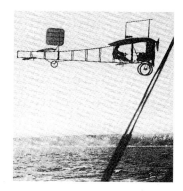

1004. Louis Blériot becomes the first person to fly over the English Channel, in an aircraft of his own construction, on July 25, 1909.

[9] The following pages correspond to Bocola, 1999, pp. 113–165.

[10] This had its impact on art. The first common action by the group of artists who gathered around Edouard Manet was against the exhibition monopoly of the official Salon des Artistes Français. They launched a strictly regulated association of artists, financed by membership dues, that enabled them to rent a space for the public exhibition of larger groups of work independently of the official Salon. On April 15, 1874, they opened the first of eight legendary group shows that have gone down in history as the Impressionist Exhibitions. Following their example, several hundred artists joined to establish in 1884 an alternative to the official Salon, known as the Salon des Indépendants, which was open without restriction to any painter or sculptor willing to pay the annual membership dues. By offering a place where avant-garde artists could exhibit, the independent Salon contributed significantly to the dissemination of new artistic impulses.

The paradigmatic significance of this transformation becomes clear in a comparison to the art currents of the outgoing era documented in the last chapter – Realism, Neoclassicism, Romanticism and Symbolism. All were object-related. Realism attempted to grasp reality in the physical density and material presence of the subject matter portrayed. Neoclassicism sought the visual as well as physical and mental equilibria of its compositions in the artistic, literary and philosophical model of classical Antiquity. Romanticism expressed its emotions and passions in the portrayal of external events. Symbolism portrayed the supernatural with the fabulous creatures and monsters of its imaginary worlds.

Whatever their respective basic attitudes, the works of these various artistic currents displayed a series of common properties:

— Each offers the observer a view on an illusionary space in which figures, objects and events are located. David shows Mars and Venus (fig. 9), Géricault shows the raft of Medusa (fig. 13), Moreau shows Oedipus with the Sphinx (fig. 45), Courbet shows two men breaking stones (fig. 21). The observer sees this space and its scenes as though through a window – separated from events, as though watching theater on a stage.
— All have a literary and narrative character. The defining artistic means consist in theatrical composition and the naturalistic painterly technique with which the subject is given its credibility.
— Thus these pictures convey to the educated observer of the time all the information required for understanding the narrative. He could locate everything that he saw in a familiar, generally valid and socially sanctioned structure of meaning. The only thing that eluded him was the creative act of the artist, for the picture conveyed no insight into its own process of creation. To lay people, the naturalistic style was something akin to a miracle, as incomprehensible as the talent of the "gifted" artist. This manner of art experience kept the observer separated from the artist.

The attitude of mind expressed in these properties – the separation of body from soul, of human from world, of observer from image – gives way to a new paradigm in the art of emergent Modernism. Its creations proceed from the idea of a holistic, scientifically formed worldview and self-image,[11] itself reflected in a series of qualities common to modernist works:

— These pictures no longer reflect an object-related world but a dynamic one. Their primary subject is not the depicted object but the creative process itself, i.e. the emotions and the aesthetic and intellectual decisions that gave birth to each artistic expression.
— Freed from the content of a painting, the artistic statement shifts to the process of painting. The artist makes the creative process visible, inviting the obser-

[11] Science abstracts from specific cases and focuses on universal and anonymous driving forces and the natural laws that underlie visible reality. This turn to the universal is also a defining characteristic of modernist art, having shaped already the work of its first exponents. In Monet's light, Cézanne's artistic order and the passionate brushstrokes of Van Gogh, the universal conditions of human existence find artistic form and expression in a universal visual language.

ver to take part in it by retracing it. The observer no longer looks into an illusory space, but at a surface – at a picture.

— The literary content of the subject declines in significance. Naturalism of portrayal gives way to the unmediated, sensual and psychic effect potential of form and color. Art speaks less to the observer's understanding and more to his pre-verbal level of experience in a fashion that eludes rational control.

— The traditional separations of mind from body, of the human being from the world, and of the picture from the observer are metaphorically eliminated: the subject and the means of depicting it become one.

Thus unchained from traditions originating in the Renaissance, European painting advances beyond the ideational framework of ancient and Christian mythology, of churchly and secular power to create a new, "enlightened" and ego-centered canon. Rapturous pathos and theatrical posturing give way to a new artistic honesty. By design the work is recognizable as a work. Modernist art strives for the insight, form, expression and meaningfulness of an indisputable reality – and finds these in the reality of individual experience. This evolution manifests the same four basic attitudes that already dominated the art of the early Modern Era, but their artistic expression reflects a new concept of self and the world.

The following pages document the beginning of this development in the period of time from 1870 to 1905. Each basic attitude is represented by one series of pictures.

The Realistic Development

The modernist Realists – Manet, Degas, Monet, Renoir and their spiritual cousins – discover in urban life a new set of artistic themes; at the same time, their work shows the subjective and sensual contingency of our visual perception. Eschewing clearly recognizable details, these artists paint grand boulevards and Seine River promenades, the new train stations and steel bridges, life in the coffee houses, restaurants and bars, the world of theater, cabaret and the "maison clôses" (figs. 52, 53, **97**, **1005**).

Monet and Renoir carry out the decisive step to Impressionism. In their pictures, visible reality loses its physical mass and becomes a mere appearance, an "impression." They do not show their subject matter as it is but as they see it. The process of perception is the subject matter of their work, not the perceived object. The medium of this process is light, the effects of which the Impressionists seek to reproduce by using pure and unbroken areas of color. Called a "liberation of color," this step initiates the artistic revolution of Modernism (figs. **50**, 51).

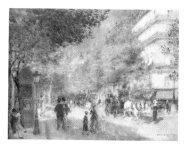

50. Pierre Auguste Renoir: *Boulevard in Paris*, 1875. Oil on canvas, 52.1 x 63.5 cm

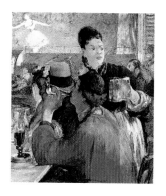

1005. Edouard Manet: *At a Café Concert*, 1878/79. Oil on canvas, 98 x 79 cm

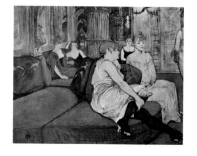

97. Henri de Toulouse-Lautrec: *Salon in the Rue des Moulins*, 1894. Black chalk and oil on canvas, 115.5 x 132.5 cm

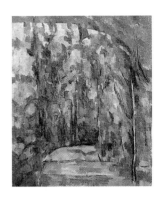

108. Paul Cézanne: *Bend in Forest Road*, 1902–1906. Oil on canvas, 81.3 x 64.8 cm

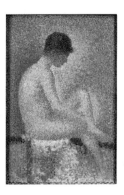

76. Georges Seurat: *Seated Model in Profile*, 1887. Oil on panel, 25 x 16 cm

The Structural Development

The structural attitude in Modernism developed along two tendencies that found their first definitive expressions in the works of Georges Seurat and Paul Cézanne.

Seurat, the founder of Pointillism, is the first artist to attempt to analyze and represent systematically the structure of the visible world. As though anticipating the photo-mechanical color lithograph, he forms his images out of an evenly placed grid of colored dots, lending to them a mechanical and impersonal character (fig. **76**) that we shall encounter in the mathematical arrangements of Concrete Art.

Cézanne's is an art of synthesis. Around 1870 he gives up his previous, romantic style of painting (fig. 59), in which violence and passion predominated, and begins to develop the painterly language that becomes the actual, pathbreaking message of his art. In his masterly late work, he flattens and spreads out the short, comma-like brushstrokes of the Impressionists, and clearly accentuates them along the vertical, horizontal or diagonal axis. Through parallel layering, repetition, and side-by-side placement, the brushstrokes yield formal patterns or force fields that are combined into wholes of graded hues and contrasts that reinforce and brace each other, that interweave and superimpose[12] (see figs. 107, **108**, 110).

Cézanne is no longer interested in the mountains, rocks and trees of his landscapes, or in the apples, glasses, and drapery of his still lifes as objects. They instead become elements of form and color within a pictorial order that reveals the immanent laws underlying all being. "*There are only colors, and in them the clarity, the being that thinks them.*"[13]
With their work, Seurat and Cézanne initiate the development that leads through Cubism to geometric nonfigurative painting.

The Romantic Development

The romantic development in Modernism is initiated by Vincent van Gogh and Paul Gauguin.

Under the influence of the Impressionists, the gloomy brown tones of Van Gogh's early, expressive art give way to the use of pure color. In 1888 he moves from Paris to Arles; beneath the searing sun of the Provence he finally finds his true artistic voice. His pictures assume a formal compactness; pure color is brought together in larger planes, the expressive line acquires dominance. His lines do not merely lend contour and volume, but become the defining element of form in the

[12] See Schmidt, 1976, p. 90f.

[13] In Gasquet, 1928, as quoted in Hess, 1988 (1956), p. 25.

pastose application of his paint. Every monochrome area is filled with linear life, causing a dramatic intensification of rhythm and expression. But in contrast to Cézanne, Van Gogh's goal is not to reveal a formal or "spiritual" structure but to express inner feelings (figs. 83, 87, 88, **1006**).

His pictures are born of faith and hope. They cry out for love, they crave mystical unification. His rhythmically modeled brushstroke and the emotional intensity of his colors testify to the passionate urge to be one with the world. In the creative act, Van Gogh overcomes the tragic alienation that causes him such anguish in real life.

Gauguin's painting is less impulsive. Stylistically he takes guidance from the Japanese woodcut, adopting its two-dimensionality, its use of pure color devoid of modeling, and its freedom of line, and using its artistic principles to sound a psychological chord. In Tahiti, he creates the famous South Sea paintings that we associate with his name. In the enigmatically distant gaze of his exotic figures, in the melodic wave of colors and in the sensually rounded contours, we can sense Gauguin's longing for authenticity, for a reconciliation with destiny and for a lost paradise of profound, eternal pleasure (figs. **89**, 111).
Following on Gauguin and Van Gogh, Matisse founds the Fauvist movement, which leads to the painterly abstractionism of Kandinsky and to emblematic Surrealism.

The Symbolist Development

At the end of the 19th century the works of two artists, Edvard Munch and James Ensor, serve to liberate the symbolist attitude from its literary dependency and give it a new creative form.

Munch and Ensor pose the question of the meaning of life. But instead of escaping to the idealized irreality of their Symbolist contemporaries, they answer by revealing their own wounds and fears (see figs. 118 to 120). Their painting unites various levels of experience in one pictorial space, and interprets visible reality as the form and expression of irrational inner ideas and visions (figs. **94**, 95, 118, 119). They pave the way for German Expressionism and figurative Surrealism.

1006. Vincent van Gogh: *Cypresses with Two Women,* 1890. Oil on canvas, 92 x 73 cm

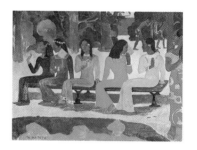

89. Paul Gauguin: *Ta matete (The Market),* 1892. Oil on canvas, 73 x 92 cm

94. James Ensor: *The Red Judge,* 1890. Oil on canvas, 46 x 38.5 cm

1870–1905. The Beginnings of Modernism

The realistic development

aims at grasping visible reality and what actually exists. Manet, Degas, Monet and their spiritual cousins discover a new set of artistic themes in big-city life, at the same time showing the subjective and sensual contingency of our visual perception.

realistic ▶

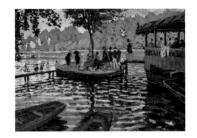

49. Monet, 1869

The structural development

is exemplified by Cézanne and Seurat, who understand their painting as an order of forms and colors, and recreate visible reality as a self-contained, purely visual structure.

structural ▶

54. Cézanne, 1869–1871

The romantic development

is exemplified by Gauguin and Van Gogh, who discover the psychic expressive power of color, and form and recreate visible reality as an unmediated emotional echo of their inner impulses and feelings.
Following on them, Matisse, Derain and Vlaminck found the Fauvist movement.

romantic ▶

59. Cézanne, 1867–1869

The symbolist development

aims at making emotional states visible by using the associative potential of external appearances and their relations to inner ideas. Munch and Ensor unite various levels of experience into a single composition and comprehend visible reality as the form and expression of irrational inner ideas and visions.

symbolist ▶

64. Hugo, 1866

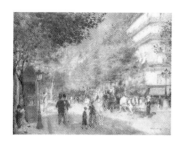
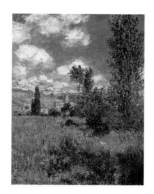
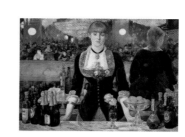

50. Renoir, 1875 51. Monet, 1880 52. Manet, 1881/82 53. Degas, 1885/86

55. Cézanne, 1875 56. Cézanne, 1879/80 57. Cézanne, 1885–1887 58. Seurat, 1884–1886

61. Van Gogh, 1885 62. Van Gogh, 1885 63. Van Gogh, 1887

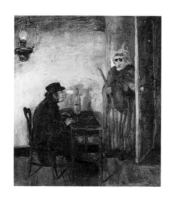

65. Puvis de Chavannes, 1879 66. Redon, 1881 67. Ensor, 1883 68. Ensor, 1886

1870–1905. The Beginnings of Modernism

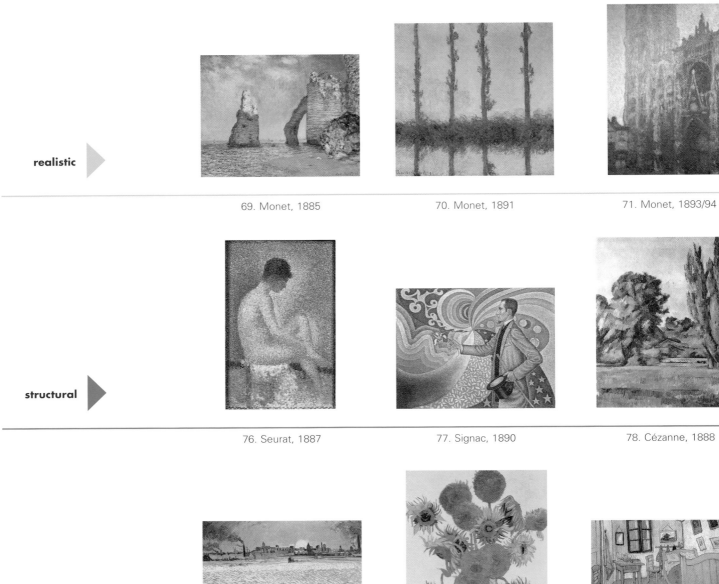

realistic

69. Monet, 1885 · 70. Monet, 1891 · 71. Monet, 1893/94

structural

76. Seurat, 1887 · 77. Signac, 1890 · 78. Cézanne, 1888

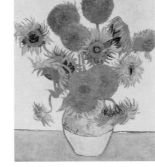

romantic

83. Van Gogh, 1888 · 84. Van Gogh, 1888 · 85. Van Gogh, 1888

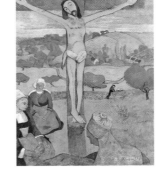

symbolist

90. Sérusier, 1888 · 91. Gauguin, 1889 · 92. Ranson, 1890

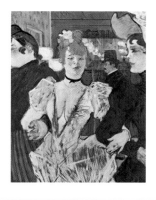

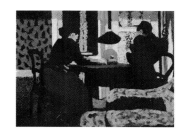

72. Toulouse-Lautrec, 1891/92

74. Vuillard, 1891/92

75. Vuillard, 1892

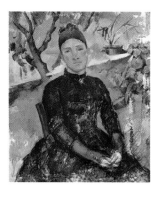

79. Cézanne, 1888–1890

80. Cézanne, 1890

81. Cézanne, 1890

82. Cézanne, 1891/92

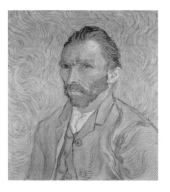

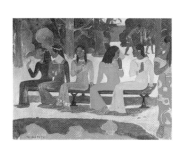

87. Van Gogh, 1889

88. Van Gogh, 1889

89. Gauguin, 1892

93. Denis, 1893

94. Ensor, 1890

95. Ensor, 1892

96. Munch, 1892

realistic

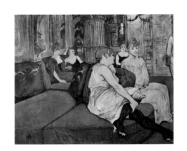

97. Toulouse-Lautrec, 1894 98. Degas, 1896 99. Degas, 1896

structural

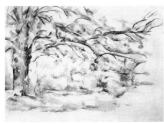

104. Cézanne, 1890–1895 105. Cézanne, 1896–1898

romantic

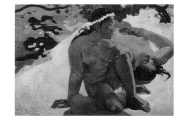
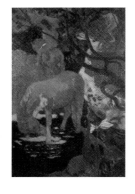
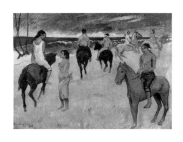

111. Gauguin, 1892 112. Gauguin, 1898 113. Gauguin, 1902

symbolist

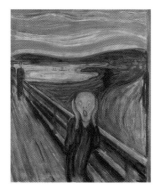
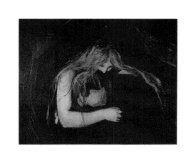
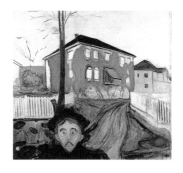

118. Munch, 1893 119. Munch, 1893/94 120. Munch, 1898–1900

100. Bonnard, 1900

102. Monet, 1904

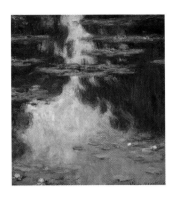

103. Monet, 1907

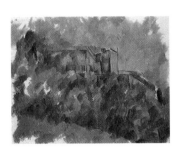

107. Cézanne, 1902–1905

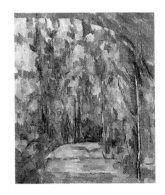

108. Cézanne, 1902–1906

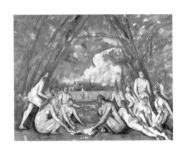

109. Cézanne, 1906

110. Cézanne, 1906

114. Matisse, 1900

115. Vlaminck, 1904

116. Derain, 1905

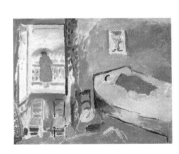

117. Matisse, 1905

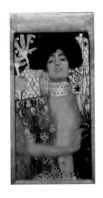

121. Klimt, 1901

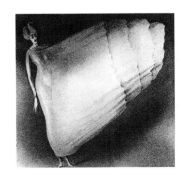

122. Kubin, 1900

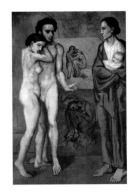

123. Picasso, 1903

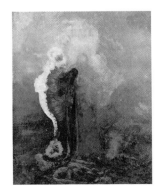

124. Redon, 1904

Pierre Bonnard 1867–1947
Paul Cézanne 1839–1906
Edgar Degas 1834–1917
Maurice Denis 1870–1943
André Derain 1880–1954
James Ensor 1860–1949
Paul Gauguin 1848–1903
Vincent van Gogh 1853–1890
Victor Hugo 1802–1885
Gustav Klimt 1862–1918
Alfred Kubin 1877–1959
Edouard Manet 1832–1883
Henri Matisse 1869–1954
Claude Monet 1840–1926
Edvard Munch 1863–1944
Pablo Picasso 1881–1973
Pierre Puvis de Chavannes 1824–1898
Paul Ranson 1862–1909
Odilon Redon 1840–1916
Pierre Auguste Renoir 1841–1919
Paul Sérusier 1864–1927
Georges Seurat 1859–1891
Paul Signac 1863–1935
Henri de Toulouse-Lautrec 1864–1901
Maurice de Vlaminck 1876–1958
Edouard Vuillard 1868–1940

1905–1945
The Aesthetics of the Universal

1905–1945. The Aesthetics of the Universal

At first, the holistic concept of the world and of the human being, on which the artistic and scientific achievements of the dawning 20th century were based, was restricted to a narrow circle of artists, scientists and intellectuals. Popular consciousness remained under the spell of the previous paradigm, meaning the values and ideas of the 19th century, and only began to change when the outbreak, course and consequences of the First World War subjected the old paradigm to radical doubt. Sociohistorically speaking, the Great War was the shaping event of a dawning modernist era, tearing the people out of all of their accustomed conditions of life and unleashing the political, economic and social forces that would shatter the existing structures of order.[14]

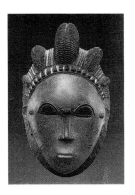

1007. *Portrait Mask, Baule,* Ivory Coast. First half of the 20th century. Hardwood with traces of paint, height 30 cm

A comparable intellectual upheaval was completed within the realm of art even before the war broke out.[15]

The work of the great modernist pioneers began to find a larger audience during the first years of the 20th century. A memorial retrospective for Georges Seurat was opened in Paris in 1900, followed by further such exhibitions in 1901 for Vincent van Gogh, in 1903 for Paul Gauguin, and in 1907 for Paul Cézanne. The impact of these shows was intensified by the simultaneous "discovery" of foreign and until then little-known artistic forms that went beyond the conventional terms of reference prevalent in Western art, most importantly the tribal art of preliterate non-European peoples and the "naive" painting of the "customs agent," Henri Rousseau.

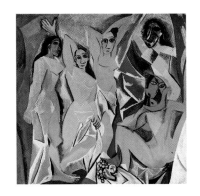

131. Pablo Picasso: *Les Demoiselles d'Avignon,* 1907. Oil on canvas, 243.9 x 233.7 cm

An impressive collection of Oceanic and African tribal art was already accessible to the Parisian public before the turn of the century, starting with the opening of the Musée d'Ethnographie du Trocadéro (today's Musée de l'Homme) in 1882, but at first this attracted a strictly anthropological interest.

On a visit to this museum in 1907, Picasso was the first to recognize instantly the expressive potential of African art, and decided to exploit it in his own work. "*At that moment,*" he remarked in retrospect, "*I realized that this was what painting was all about.*"[16] The overwhelming impact of this visit is reflected in the final version of *Les Demoiselles d'Avignon,* which he completed shortly thereafter (fig. **131**). Not only does this painting shock the artists, writers, collectors, and dealers who see it in his studio; it also arouses their interest in African tribal art, which henceforth is presented more and more often in exhibitions and periodicals, in combination with the works of the European avant-garde.

In the creative power and in the inventiveness of these unconventional figures and forms (fig. **1007**), modernist artists saw an important confirmation of their own efforts to find new, vital forms of expression and a new, elementary visual language. However, tribal art did not cause a fundamental reorientation of mod-

[14] The Russian Revolution, the collapse of the European monarchies, the diffusion of socialist, communist and fascist movements, the founding of the League of Nations, the emancipation of women – all of these developments may be seen as direct or indirect consequences of the First World War.

[15] The following passages correspond to Bocola, 1999, pp. 167–223.

[16] Quoted in Rubin, vol. 1, 1984, p. 334, note 8.

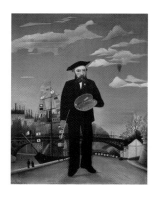

1008. Henri Rousseau: *Myself, Portrait and Landscape,* 1890. Oil on canvas, 143 x 110 cm

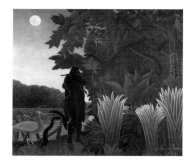

1009. Henri Rousseau: *The Snake Charmer,* 1907. Oil on canvas, 169 x 189.5 cm

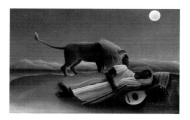

1010. Henri Rousseau: *Sleeping Gypsy,* 1897. Oil on canvas, 129.5 x 200.7 cm

ernist painting, but rather reinforced and sanctioned developments that were already going full steam.

Modernist art received a second defining impulse through the work of Henri Rousseau.

An employee of the Parisian municipal customs office without any previous training in the arts, Rousseau around 1875 begins to paint. The pictures that he exhibits every year at the jury-less Salon des Indépendants manifest great painterly qualities but also evince inept draftsmanship, which earns them the scorn and derision of the press and public. Spiting this hostility, Rousseau continues to exhibit at every Salon. He becomes an annual, anticipated source of amusement and, in time, something of a celebrity. Gradually, in addition to mockers and scoffers, he begins to attract the attention of artists and art lovers who recognize his greatness as an artist. Their admiration goes especially to his late jungle paintings. His naive concept of reality, vivid forms, rich, finely graded colors and the strong rhythm of his masterpieces exercised a decisive influence on the realistic ambitions of the contemporary avant-garde, especially on Picasso, Léger and De Chirico (see figs. **1008**, **1009**, **1010**).

A further tremor shook the dominant artistic standards with the increasing diffusion and technical perfection of photography. The enormous experience, skill and effort required until then to create a naturalistically faithful reproduction of reality was reduced to a few technical motions of the hand. The illustrative function of painting seemed to have been robbed of any meaning.

The confrontation with these strange-seeming aesthetic concepts and with the works of the great pioneers – Seurat, Cézanne, Gauguin and Van Gogh – set in motion the developments that led to nonfigurative art on the one side and to a new, surreal figuration on the other. In the service of clarity, we will follow these two simultaneous developments in separate subchapters.

We begin by documenting the development towards nonfigurative art. This in turn we divide into three stages: the first occurring in the period from 1905 to 1925; the second following a parallel development limited to Russia in the years 1910 to 1920; and the third covering the period from 1925 to 1945.

We will subsequently follow the simultaneous rise and development of a new figurative painting in the same overall period from 1905 to 1945.

The Way to Nonfigurative Art
1905–1925. The First Developmental Stage

Both the structural and romantic attitudes of mind drove artistic development towards nonfigurative forms. In their painting, the exponents of these two attitudes increasingly distanced themselves from visible appearances. Gradually but inevitably they advanced towards the elementary, the general and the universal in an effort to lend creative expression to an invisible reality. Their painting is concerned with the two basic conditions of all life, structure and energy, and with their visual counterparts, form and color. Two different currents of nonfigurative art arise, corresponding to the two attitudes underlying their creation. One is structural and emphasizes form; the other is romantic and emphasizes color.[17] Our survey accordingly devotes separate rows of pictures to each of these two directions.

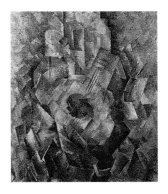

129. Georges Braque: *Mandolin,* 1909/10. Oil on canvas, 71.1 x 55.9 cm

The Structural Development
From Cubism to geometric nonfiguration

The discovery of black African sculpture around 1906 and the big Cézanne exhibition of 1907 are the two seminal impulses that lead Georges Braque and Pablo Picasso to invent the new stylistic form of Cubism and hence establish the artistic prerequisites for a geometric and nonfigurative art.

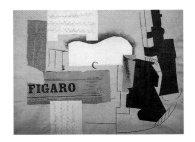

150. Pablo Picasso: *Guitar, Newspaper, Glass and Bottle,* 1913. Pasted paper and ink, 46.5 x 62.5 cm

First row of pictures: After Picasso's "époque nègre" (which was inspired by African tribal art and is shown here in the second row of pictures, figs. 130 to 132) and Braque's early cubist pictures inspired by Cézanne (figs. 125, 126), the first, "analytical" phase of Cubism begins in 1909. Braque and Picasso adopt the structural approach from Cézanne's late period, but not the coloring. Their rhythmical fragmentation of body and space into cubist facets serves to de-construct the shape of things, step by step, and to create a crystal-like structure that is self-contained, i.e. independent of the object. The pictures lose their conventionally figurative legibility and become autonomous formal configurations (fig. **129**).

In the second, "synthetic" phase of Cubism, the single elements increase in size, the formal means become more spare, and the contrasts intensify. The cubist effect gives way to variable configurations of superimposed, overlapping and sometimes transparent planes. In 1911 Braque begins to insert single letters or whole words into the planes (fig. 145) and in 1912 he sticks a piece of printed imitation wood into the picture and thus introduces the principle of collage that is then adopted by Picasso and Gris (figs. 146, **150**, 181).[18]

The Cubists no longer aim to interpret or extract a form out of givens, but instead use things and purely formal elements to construct a new reality. The picture itself becomes the object.

[17] The following passages correspond to Bocola, 1999, pp. 185–223.

[18] The most varied items and materials are henceforth used to add novel tactile qualities to pictures: newspaper clippings, colored bits of paper, imitation marble and wood, wallpaper, fabrics, basketwork. These fragments of everyday life resemble quotations – they stand in for the whole, which is now "seen" and experienced with an intensity that a naturalistic representation could never achieve.

155. Piet Mondrian: *Flowering Apple Tree,* 1912. Oil on canvas, 78 x 106 cm

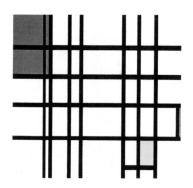

257. Piet Mondrian: *Rhythm of Black Lines,* 1935–1942. Oil on canvas, 68.9 x 71.4 cm

159. Henri Matisse: *Spanish Still-life,* 1911. Oil on canvas, 89 x 116 cm

[19] Mondrian was originally a Symbolist (fig. 141). After his first exposure to the cubist works of Braque and Picasso he gave up on his previous painting and went through the abrupt change in style with which he initiated the development from Cubism to geometric abstraction.

Second row of pictures: Cubism enters its most fruitful and surprising stage in the work of the Dutchman Piet Mondrian.[19] Starting with the representation of a tree, he moves on in 1912 to an emphatically linear abstraction, paring his subject matter down to a rhythmical play of curved and straight lines (fig. **155**). In 1914 he creates his first entirely nonfigurative pictures (figs. 157, 158, 180). An unwavering process of simplification ensues. Step by step, Mondrian bans all remaining "disturbing" elements (arches, diagonals, non-primary colors) from his arsenal and, from 1925 forward, limits it to three elements of design: a white ground, vertical and horizontal black bands, and the three primary colors yellow, blue, and red (fig. **257**).

With like-minded artists such as Van Doesburg (figs. 182, 185) and Van der Leck (fig. 181), Mondrian founds the De Stijl movement – an association of painters, architects and designers who hope to subordinate the form of all human artifacts to a unified aesthetics based on functionality, geometry and logic, with the goal of creating a humane environment that corresponds to the enlightened spirit of the new age.

Together with related movements like Bauhaus, the De Stijl group established rationally verifiable and "universal" aesthetic standards that defined much of the appearance of technical-industrial civilization in the 20th century.

The Romantic Development
From Fauvism to Painterly Abstraction

Third row of pictures: The Romantic development towards nonfigurative art began with the movement of the Fauves, who gathered around Henri Matisse during the first years of the 20th century (see figs. 114 to 117 in the previous chapter). Matisse and his friends (Derain, Vlaminck, Marquet et al.) looked to Gauguin and Van Gogh, adopting the former's pure and planar color and the latter's spontaneous brushstroke and compact, pastose application of paint. Unlike their expressionistic predecessors, however, they do not use these techniques to voice individual longings or erotic desires, but to create a purely pictorial vision. Matisse turns to a decorative painting style, in the best sense of the word (see figs. **159**, 160, 164, 191, 193), in the process adopting the colors and patterns of Spanish and Oriental carpets and textiles. Without surrendering the object, he recreates his motifs (still lifes, interiors and his famous odalisques) as colorful structures. Finally, late in life, he creates with a series of masterful gouaches découpées (cut-outs, figs. 291, 292 and figs. 463, 488 on pp. 95, 96) the basis for a decorative, colorful and planar abstraction that is taken up in America by the Color Field Painting of the 1960s (see pp. 93–99).

Under the influence of the Fauves, German variants of Fauvism arise with the artists group "Die Brücke" in Dresden, which gathers in 1904 around Ernst Ludwig Kirchner (fig. 162) and the circle that forms in 1909 in Munich around the Russian painter Wassily Kandinsky.

170. Wassily Kandinsky: *Improvisation 26 (Rudders)*, 1912. Oil on canvas, 97 x 107.5 cm

■ *Fourth row of pictures:* Kandinsky takes the decisive step to gestural nonrepresentational painting in 1912 with a series of what he calls "improvisations," in which line and color are the sole objects of depiction (figs. **170**, 171, 197, 198). Carefully studying late cubist pictures and Russian Suprematism, Kandinsky devises starting in 1922 a geometric orchestration and order of his own, in which the diverse of chromatic tones and formal rhythms are united in a complex and comprehensive pictorial whole (see figs. 262, 263, 289, 290, 293 on pp. 67–69).

Kandinsky's most important kindred soul is Paul Klee. Without entirely abandoning the representation of the object, he turns away from external reality and toward the inner world of fantasy and dreams. But he does not lose his way in the depths of the unconscious. Still a young man, he remarks in his diary: "*Now, my immediate and at the same time highest goal will be to bring architectonic and poetic painting into a fusion, or at least to establish a harmony between them.*"[20]

195. Paul Klee: *Above the Mountain Peaks*, 1917 (75). Watercolor on paper, 31 x 24.1 cm

Klee subjects the painted object to extreme alienation: on one hand, it is detached from its natural context and related in a new, irrational way to other objects and also to signs, patterns, and nonrepresentational elements of form; on the other hand, the object itself acquires emblematic traits and is linked to the other pictorial elements in an entirely unorthodox and complex manner that yields an enigmatic, magical effect (fig. **195**). Klee's signs and symbols are ambiguous, they arouse inner whisperings and ideas, but they can rarely be pinned down to logical meaning. These works have a surrealist character and are documented here within the timeline of symbolist development, on p. 78 (figs. 363, 367, 421). But Klee operates on several levels of style: his nonrepresentational pictures (see fig. 199 on p. 55 and figs. 235, 236, 239, 264 on pp. 64–67) are expressions of the romantic development. Both sets of paintings attest to an attitude that listens with a powerful inner ear, in which the hand of the artist, as Klee puts it, becomes "*entirely the instrument of a foreign will.*"[21]

[20] Klee, 1964, p. 125 (July 1902).

[21] Klee, 1928, quoted in Geelhaar, 1982, p. 55.

The Way to Nonfigurative Art
1905–1925. The First Developmental Stage

The confrontation with the works of the great pioneers – Seurat, Cézanne, Gauguin and Van Gogh – set in motion around 1905 the developments that within a few years led to nonrepresentational art.

The structural development
towards nonfigurative art is documented in the top two rows of pictures.
The first leads from the Cubism of Braque, Picasso and Gris to the geometric nonrepresentational art of the Constructivists.

The second leads from Cubism to the geometric non-representational art of Mondrian and Doesburg and the De Stijl movement, which also influenced Bauhaus.

The romantic development
towards nonfigurative art is documented in the bottom two rows.
The third row leads from French and German Fauvism to the decorative painting of the mature Matisse.

The fourth row leads from the early Kandinsky to the painterly and poetic nonrepresentational art of Kandinsky, Klee and Miró.

structural

125. Braque, 1907

structural

130. Picasso, 1907

romantic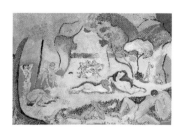

135. Matisse, 1905/06

romantic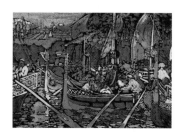

140. Kandinsky, 1906

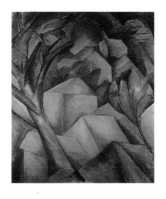 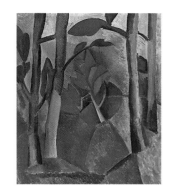 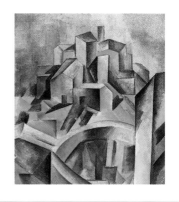 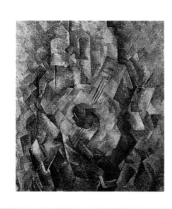

126. Braque, 1908 127. Picasso, 1908 128. Picasso, 1909 129. Braque, 1909/10

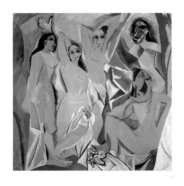

131. Picasso, 1907 132. Picasso, 1908 133. Léger, 1909–1911 134. Léger, 1910/11

 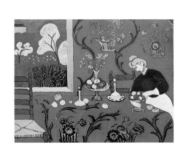 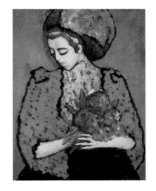 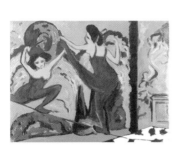

136. Derain, 1906 137. Matisse, 1908 138. Jawlensky, 1909 139. Kirchner, 1909

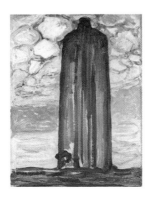

141. Mondrian, 1908 143. Kandinsky, 1908 144. Kandinsky, 1909

structural ▶

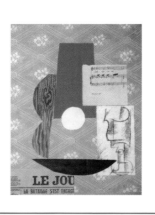
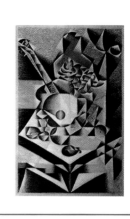

145. Braque, 1912 146. Picasso, 1912 147. Gris, 1912

structural ▶

152. Delaunay, 1911 153. Léger, 1912 154. Mondrian, 1911/12

romantic ▶

159. Matisse, 1911 160. Matisse, 1912 161. Marc, 1912

romantic ▶

166. Kandinsky, 1910 167. Kupka, 1911

52

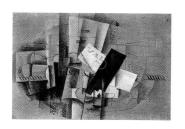

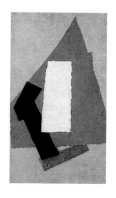
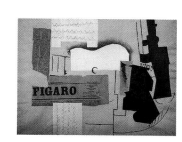

148. Braque, 1913 149. Picasso, 1913 150. Picasso, 1913 151. Picasso, 1913

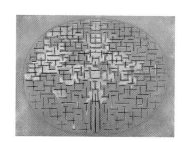
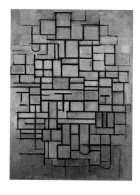

155. Mondrian, 1912 156. Léger, 1913 157. Mondrian, 1914 158. Mondrian, 1914

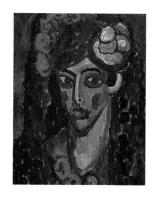
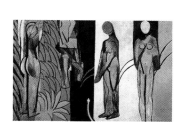

162. Kirchner, 1913 163. Jawlensky, 1913 164. Matisse, 1913 165. Matisse, 1914

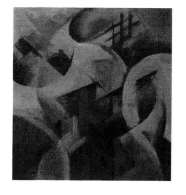

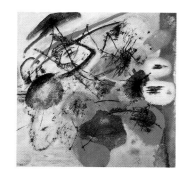
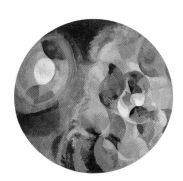

169. Marc, 1913 170. Kandinsky, 1912 171. Kandinsky, 1913 172. Delaunay, 1913

The Way to Nonfigurative Art
1905–1925. The First Developmental Stage

structural ▶

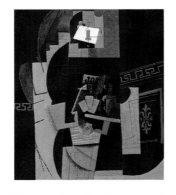 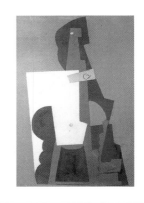

173. Picasso, 1913/14 174. Gris, 1916 175. Laurens, 1917/18

structural ▶

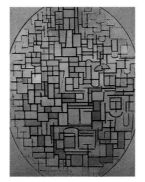

180. Mondrian, 1914 181. Van der Leck, 1917 182. Van Doesburg, 1918

romantic ▶

187. Nolde, 1914 188. Matisse, 1917 189. Matisse, 1918

romantic ▶

194. Klee, 1915 195. Klee, 1917

176. Braque, 1919 177. Picasso, 1921 178. Baumeister, 1923 179. Moholy-Nagy, 1924

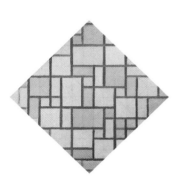
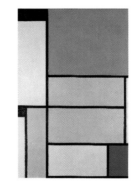

183. Mondrian, 1919 184. Mondrian, 1921 185. Van Doesburg, 1925 186. Dexel, 1925

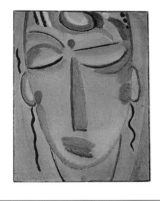

190. Jawlensky, 1918 191. Matisse, 1920/21 192. Beckmann, 1924 193. Matisse, 1925/26

197. Kandinsky, 1920/21 198. Kandinsky, 1921 199. Klee, 1922 200. Miró, 1925

The Way to Nonfigurative Art
1912–1922. The Russian Avant-Garde

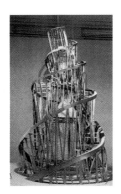

205. Vladimir Tatlin: *Monument to the Third International,* model, 1919, reconstruction of 1987–1991

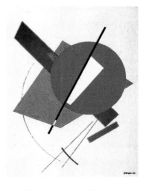

211. Ivan Kliun: *Abstract Composition,* 1920. Oil on canvas, 92 x 68 cm

The developments through 1925 as documented on the preceding pages took place primarily in western Europe, above all in Paris. Before following these lines on to 1945, we shall first treat a parallel development in Russia.[22]

Soon after Cubism and Fauvism arose, a series of exhibitions served to make these new currents known in all major European cities. Countless artists adopted the new visual language, although most of them merely picked up the external properties while continuing to follow a broad variety of different artistic attitudes and goals. Everywhere there formed "revolutionary" art groups and movements, issuing manifestoes and proclamations to raise the hope of a completely new, unprecedented art and a new feeling of life that would surpass everything that had come before.[23]

The most fertile attempt to fulfill the expectations thus roused and to create a truly new, futuristic art was undertaken in Russia.

Russians first entered decisively into unexplored artistic terrains in 1915 with the legendary Petersburg show, "Last Futurist Exhibition: 0.10", which included works by, among others, Kazimir Malevich and Vladimir Tatlin. Both of these artists proceeded from Cubism, whereby Tatlin initiated the structural and Malevich the romantic development towards nonfigurative art; known respectively as Constructivism and Suprematism, these were the most essential Russian contributions to the art of Modernism.[24]

The Structural Development: *Russian Constructivism*

Inspired by Picasso's Cubist reliefs, which he saw in the Spaniard's studio during a visit to Paris in 1914 (fig. 151), Tatlin presented a group of free-hanging, completely abstract material constructions made of metal, wood and glass (fig. 202).[25] Later he turned to projects of sculptural architecture (fig. **205**). With these works, which attracted great attention at the time, Tatlin founded the movement of Russian Constructivism, the exponents of which endeavored to create a new aesthetic compatible with the technicized world, free of lyricism, sentimentality and any form of bourgeois convention (fig. **211**). Many of these artists accordingly occupied themselves with architecture, product design, textile design, typography, photography and advertising.

[22] See Bocola, 1999, pp. 308–315.

[23] While Italian Futurism and Dadaism received the most attention at the time, I unfortunately cannot cover these in detail here. See the corresponding sections in my textbook, Bocola, 1999, pp. 301–308 and 316–321.

[24] Many exponents of the Russian avant-garde pursued both structural and romantic concerns; artists like Popova, Kliun or Rodchenko are therefore represented in both rows of pictures (figs. 201 and 209, 212 and 218, 221, 211 and 223, 224).

[25] These works survive only in a few photographs and later reconstructions (fig. 202).

The Romantic Development: *Russian Suprematism*

At the same legendary exhibition in 1915, Malevich showed a series of geometric abstract works, including the astonishing and now famous 80 cm x 80 cm picture on which nothing can be seen other than a black square on a white ground (fig. **207**). Other, similarly terse compositions replaced the square with a cross, a single bar, or a trapezoid dominating a white canvas, but Malevich also showed pictures in which a variety of colorful rectangles and quadrilaterals come together in dynamic, rhythmic compositions (fig. **208**). With these abstract works, Malevich founded the movement of Suprematism; later its forms would have a defining impact on American painting in the 1960s.

Unlike artists such as Mondrian or Doesburg, Malevich and like-minded colleagues were not out to create a new structure of visual order, but to express and give form to the *"supremacy of pure feeling,"* the mystical vision of a *"world without objects."*[26] Thus, despite their use of a geometric visual language, the works of the Suprematists are here ordered within the romantic attitude because of their irrational and emotional preoccupation (fig. **223**).

With the victory of the October Revolution, the Russian avant-garde met suddenly with unconditional official recognition. The artists left their studios to devote themselves, as civil servants, to the creation of a new, revolutionary infrastructure for art. Art schools and museums were founded, associations and commissions formed, pictures purchased, guidelines defined and programs designed for schools, exhibitions and museums.[27]

But the revolutionary government's modernist euphoria was of brief duration. Lenin's New Economic Policy in 1921 put an end to the concord between Art and the State that had arisen after the Revolution. Constructivism and Suprematism were henceforth discredited as strategies for exerting a desirable influence on the people; in the 1930s that role was played by Socialist Realism.

Many Russian artists emigrated. Through their contributions to the work of the Dutch De Stijl group and Bauhaus, they continued to influence the subsequent development of Western art. In the Soviet Union, however, Modernism was condemned to silence. Thus ended the great experiment that we document on the following four pages.

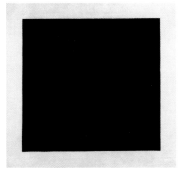

207. Kazimir Malevich: *Black Square on White Background*, 1914. Oil on canvas, 110 x 110 cm

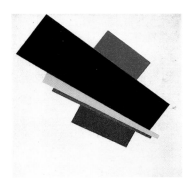

208. Kazimir Malevich: *Suprematism, 18th Construction*, 1915. Oil on canvas, 53 x 53 cm

223. Ivan Kliun: *Spherical Composition*, 1923. Oil on canvas, 64.5 x 64.5 cm

[26] Malevich, 1927, quoted by Nakov, 1984, p. 14, 16.

[27] Kandinsky, forced by the outbreak of World War I to return to his home in Russia, also participated starting in 1917 in the creation of new museums and in organizing arts education.

The Way to Nonfigurative Art
1912–1922. The Russian Avant-Garde

The Russian avant-garde developed along a structural and a romantic direction.

The structural development
leads from Cubism to Russian Constructivism, the exponents of which strive to create a new aesthetics compatible with the technicized world.

structural ▶

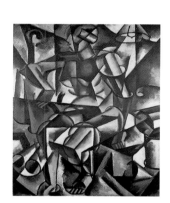

201. Popova, 1913/14

The romantic development
leads from Cubism to the geometric and abstract art of Suprematism; its mystical and meditative works lend expression to a romantic attitude.

romantic ▶

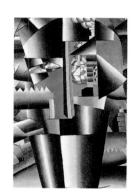

206. Malevich, 1913

Many exponents of the Russian avant-garde pursued both structural and romantic concerns; artists like Popova and Rodchenko are therefore represented in both of the above rows.

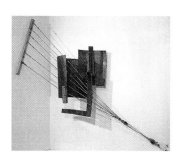

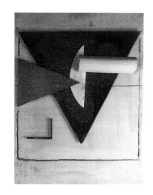

202. Tatlin, 1915–1925 203. Puni, 1915 204. Tatlin, 1916 205. Tatlin, 1919

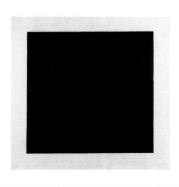

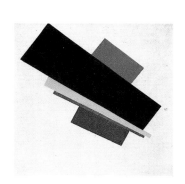

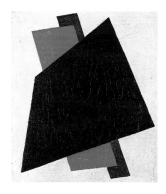

207. Malevich, 1914 208. Malevich, 1915 209. Popova, 1916/17 210. Rosanova, 1917/18

The Way to Nonfigurative Art
1912–1922. The Russian Avant-Garde

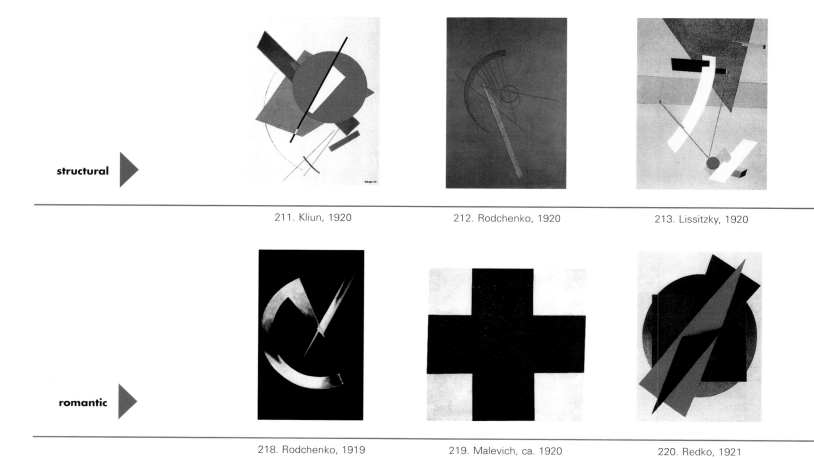

structural ▶

211. Kliun, 1920 212. Rodchenko, 1920 213. Lissitzky, 1920

romantic ▶

218. Rodchenko, 1919 219. Malevich, ca. 1920 220. Redko, 1921

214. Ioganson, 1921 215. Chashnik, 1921 216. Gabo, 1923 217. Lissitzky, 1923

221. Rodchenko, 1921 222. Malevich, 1922 223. Kliun, 1923 224. Kliun, 1923

The Way to Nonfigurative Art
1925–1945. The Second Developmental Stage

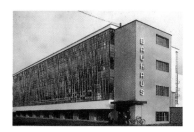

1011. View of the Bauhaus building in Dessau from the southwest, workshop entrance

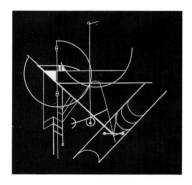

251. Walter Bodmer: *Wire Picture,* 1937–1939. Wood and iron, 150.5 x 225.5 cm

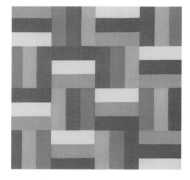

285. Richard Paul Lohse: *Color Fields Arranged in Squares,* 1944/2. Oil on canvas, 50 x 50 cm

[28] See Bocola, 1999, pp. 329–332.

[29] In addition to renowned architects like Hannes Meyer and Marcel Breuer, Gropius also succeeds in attracting to his school such celebrated artists as Albers, Kandinsky, Klee and Moholy-Nagy. Courses systematically investigate visual and physical problems of light, color and space; the psychic, expressive potential of artistic means and materials; and fundamental aesthetic issues.

Following our look at the Russian avant-garde, let us return to the paths followed by nonfigurative art in western Europe. We shall continue to distinguish therein between a structural and a romantic development.

The Structural Development
Constructivism between intuitive and mathematical order

After the accomplishments of Mondrian, Doesburg, Malevich and Tatlin, for a growing number of young artists geometric nonrepresentative painting becomes the only means by which they can lend form and expression to their own self-concept and worldview.[28]

The intellectual center of this development is at Bauhaus (fig. **1011**), a school of architecture, fine and decorative arts founded in 1919 by Walter Gropius in Weimar with the objective of bridging the gulf between everyday life and the world of the mind.[29] In its search for a comprehensive approach to life, Bauhaus aspires to fuse art and industry by adopting the values of clarity, objectivity and functionality – in effect espousing the same basic approach as the Dutch group De Stijl and the Constructivists who emigrated from Russia. These groups' common goal of fusing art, architecture and industry leads to the uncontested domination of a geometrical visual idiom and to the articulation of requisite aesthetic criteria that define not only the subsequent development of constructive nonfigurative art internationally, but also the architecture, industrial design, photography, typography and graphics of Modernism for decades to come.

In all the countries of Europe and the Americas, constructivist artists form national movements that remain united supra-nationally by shared ideals. After the De Stijl group disbands, Herbin and Vantongerloo found the "Abstraction – Création" group in Paris in 1931, which at its peak links more than 400 painters and sculptors around the world.

The products of this tendency are documented in two rows of pictures. The first shows a development that proceeds from late Cubism and Russian Constructivism; the second leads from the De Stijl movement to the Concretists of Zurich.

First row of pictures: Late Cubism and Russian Constructivism find continuation in a geometric, nonrepresentational art characterized by a pleasure in experimentation, a variety of spontaneous ideas, the use of unorthodox materials and techniques like glass, wire and metal (figs. 225, 226, 247, 250, **251**) and a baroque capacity for invention.

Second row of pictures: Parallel to the playful variants of geometric abstraction, the artists who share a common cast of mind with Mondrian and Doesburg evince a growing tendency towards discipline and systematization. This development culminates in a purist constructivism increasingly oriented to mathematical principles, as in the work of the "Zurich Concretists" Max Bill and Richard Paul Lohse (figs. 258, 281, **285**).

The Romantic Development
The development towards emblematic Surrealism

Starting in 1925, the development of painterly nonfigurative art displays two tendencies: pictorial space is organized either as a set of planes or as a set of lines.

Third row of pictures: The visual and color achievements of the first developmental stage, as documented in the previous chapter, now move forward into a baroque, decorative form of painting that emphasizes color and planes, proceeding from the geometrical tendencies of Klee's compositions (figs. 235, 236, 239) and the "Orphist" works of Kupka (fig. 260) and Delaunay (fig. 261) to the ornamental abstraction of the mature Kandinsky (figs. 262, 263, 290, 293) and the late period of Matisse (figs. 265, 291, **292**).

Fourth row of pictures: Parallel to that development, Miró and Masson pick up from the early Kandinsky and initiate, under the direct influence of Klee, an almost nonfigurative, abstract painting style that becomes known as emblematic Surrealism.[30] This is characterized by a gestural automatism in which spontaneous motor impulses are directly transferred into the picture, apparently without any censoring function, forming seemingly organic, largely abstract configurations (figs. 240, 241, **269**, 270, 271, 294, 297).

During the Second World War, many of the European Surrealists emigrated to the United States, where the new painting style was also adopted by American painters, among them Gorky, Pollock and Rothko (figs. 298–300). They in turn advanced the tendency further in the late 1940s, initiating Abstract Expressionism.

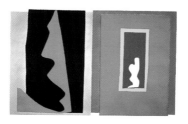

292. Henri Matisse: *Destiny*, 1943/44. Design for the book *Jazz*. Gouache cutout, 42.2 x 65.5 cm

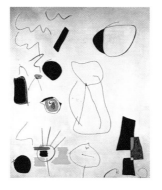

269. Joan Miró: *Moving Landscape*, 1935. Oil on canvas, 250 x 200 cm

[30] Surrealist painting, to which we shall return later on, may be divided into two clearly different stylistic tendencies: the emblematic Surrealism initiated by Masson and Miró originates from a romantic attitude; while the figurative Surrealism that we shall document in the next chapter is an expression of the symbolist tendency. The only common denominators connecting the two currents lie in their shared concern with the unconscious and their belief in psychic automatism, the process postulated by André Breton in which the artist is expected to switch off any form of control exercised by reason and "automatically" record without reservation the impulses, ideas and thoughts that arise from the unconscious.
See my discussion of surrealist painting and psychic automatism in Bocola, 1999, pp. 341–360.

The Way to Nonfigurative Art
1925–1945. The Second Developmental Stage

Following our digression on the Russian avant-garde, we return to western Europe to follow the development of nonfigurative art through 1945. This developed along both structural and romantic tendencies.

The structural development
is documented here in two rows of pictures.
The first shows the works of artists who pursue a playful, intuitive, experimental treatment of geometric pictorial idiom.

The second row follows the purist current of Constructivism, leading from the De Stijl movement and Bauhaus to the Concrete Art of Zurich, which takes mathematical principles as its guide.

The romantic development
is also documented in two rows of pictures.
The first encompasses a broad spectrum of nonfigurative articulations ranging from the geometric compositions of Klee and the "Orphist" works of Kupka and Delaunay to the ornamental plaques of the mature Kandinsky and the découpages of Matisse's late period.

The second row encompasses the emblematic Surrealism initiated by Miró and Masson and continued by Matta; its almost nonfigurative, abstract painting style is adopted in the 1940s by the Americans Pollock and Rothko, the later initiators of Abstract Expressionism.

structural ▶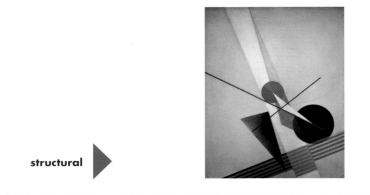

225. Moholy-Nagy, 1925

structural ▶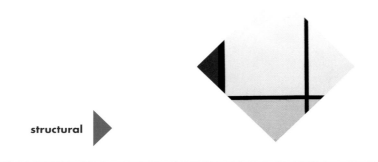

230. Mondrian, 1925

romantic ▶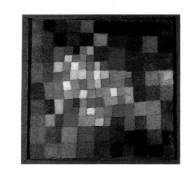

235. Klee, 1925

romantic ▶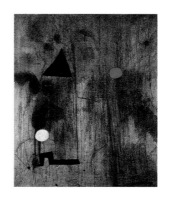

240. Miró, 1925

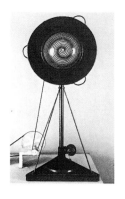 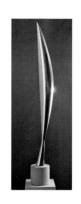 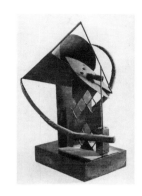 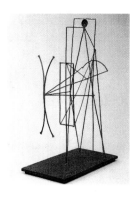

226. Duchamp, 1925 227. Brancusi, 1926 228. González, 1927–1930 229. Picasso, 1928

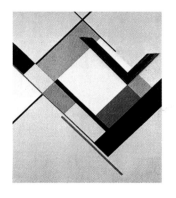 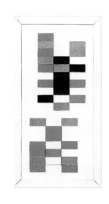 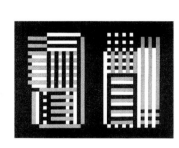 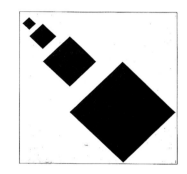

231. Vordemberge-Gildewart, 1926 232. Taeuber-Arp, 1927 233. Albers, 1929 234. Van Doesburg, 1930

 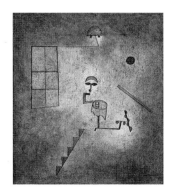 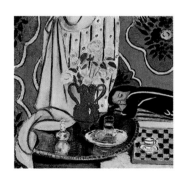

236. Klee, 1927 237. Klee, 1927 238. Matisse, 1928 239. Klee, 1929

 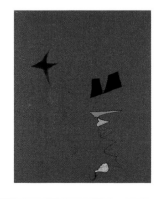 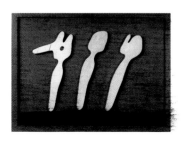

241. Masson, 1924 242. Miró, 1927 243. Miró, 1927 244. Arp, 1927

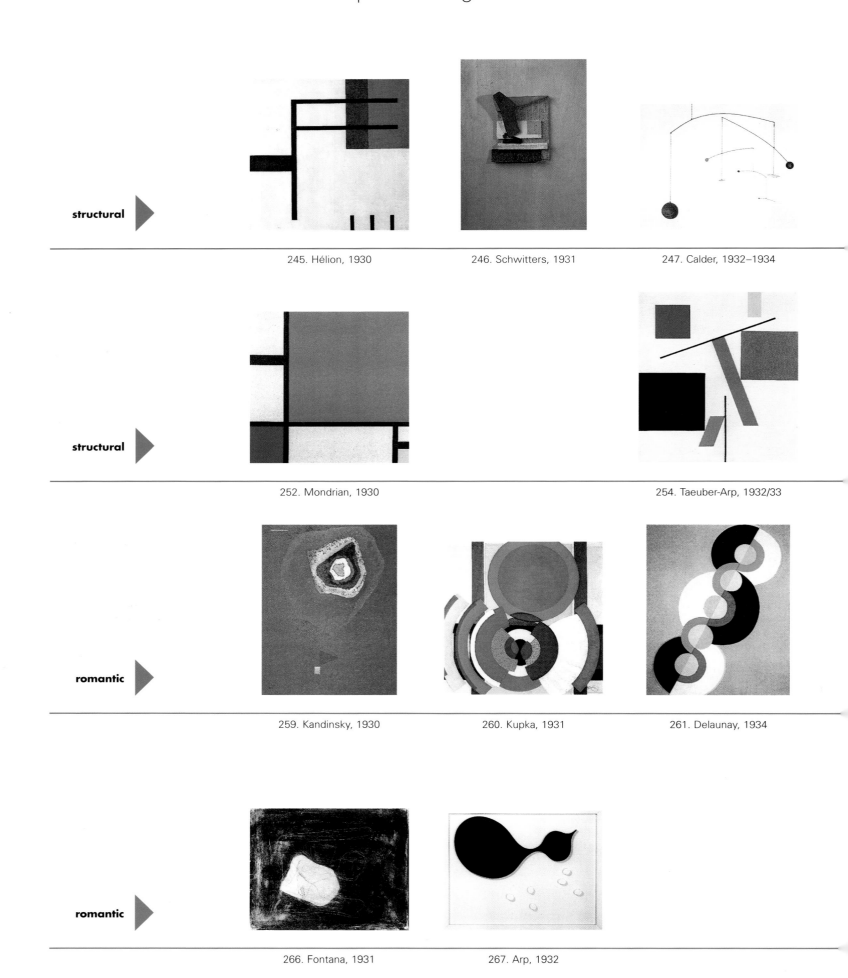

structural ▶

245. Hélion, 1930 246. Schwitters, 1931 247. Calder, 1932–1934

structural ▶

252. Mondrian, 1930 254. Taeuber-Arp, 1932/33

romantic ▶

259. Kandinsky, 1930 260. Kupka, 1931 261. Delaunay, 1934

romantic ▶

266. Fontana, 1931 267. Arp, 1932

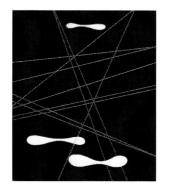

249. Vézelay, 1936

250. Domela, 1936

251. Bodmer, 1937–1939

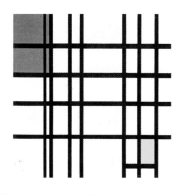

255. Taeuber-Arp, 1933

256. Mondrian, 1935–1942

257. Mondrian, 1935–1942

258. Bill, 1938

262. Kandinsky, 1934

263. Kandinsky, 1936

264. Klee, 1937

265. Matisse, 1937/38

269. Miró, 1935

270. Miró, 1936

271. Miró, 1937

272. Hartung, 1938

The Way to Nonfigurative Art
1925–1945. The Second Developmental Stage

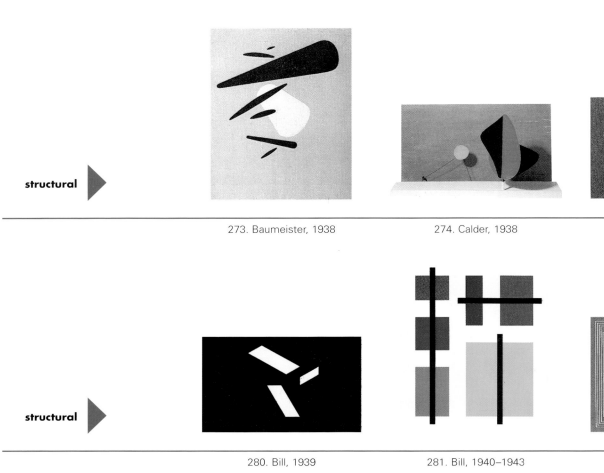

structural ▶

273. Baumeister, 1938 274. Calder, 1938 275. Eble, 1938/39

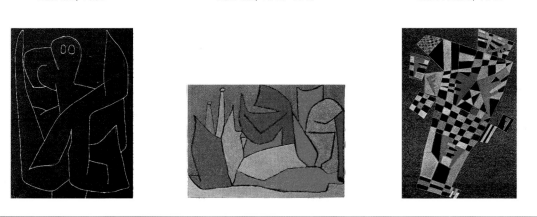

structural ▶

280. Bill, 1939 281. Bill, 1940–1943 282. Albers, 1942

romantic ▶

287. Klee, 1939 288. Klee, 1940 289. Kandinsky, 1941

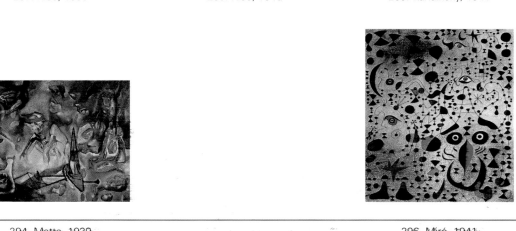

romantic ▶

294. Matta, 1939 296. Miró, 1941

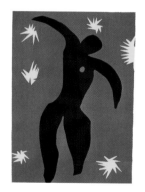

276. Gabo, 1942/43

277. Schwitters, 1943

279. Arp, 1944

283. Mondrian, 1942/43

284. Glarner, 1944

285. Lohse, 1944

286. Bill, 1946

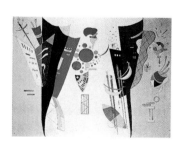

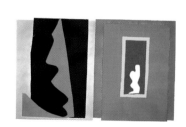

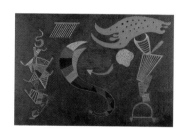

290. Kandinsky, 1942

291. Matisse, 1943

292. Matisse, 1943/44

293. Kandinsky, 1943

297. Masson, 1942

298. Gorky, 1943

299. Rothko, 1944

300. Pollock, 1944

The Way to a New Figuration
1905–1945

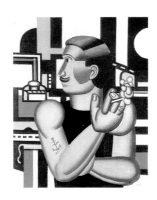

327. Fernand Léger: *The Mechanic,* 1920. Oil on canvas, 115.5 x 88.5 cm

354. Stuart Davis: *Odol,* 1924. Oil on canvas, 61 x 46 cm

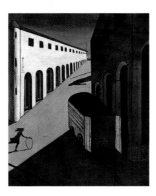

314. Giorgio de Chirico: *Mystery and Melancholy of a Street,* 1914. Oil on canvas, 87 x 71.5 cm

At the same time as Mondrian and Kandinsky complete their pioneering steps towards a nonfigurative art, a series of artists enter the scene to relativize their achievements by charging the object of art with meaning in a completely new, unexpected and unsettling way, thereby initiating the development to a new figuration. This in turn is carried by the realistic attitude on one hand, and by the symbolist attitude on the other.[31]

The Realistic Development
From Futurism to emblematic and magic realism

First row of pictures: After its onset, Cubism gains a growing number of followers in the major European cities. Even as the Constructivists continue developing the structural concepts of Cubism towards geometric abstraction, other artists press its tools into the service of realistic tendencies. Around 1920, they proceed from the ideas of Cubist collage to an object-related art that takes inspiration and appropriates its design elements from the visual culture of urban life and the styles of the mass media, advertising, posters, store window displays, catalogues, newspapers and periodicals.

The most important exponent of this current is the former Cubist Fernand Léger, who after completing his military service in 1919 turns away from Cubism and translates his vision of a mechanized world into an aggressive and vivid visual idiom that secures his place among the great masters of Modernism (figs. **327**, 351, 352). His glorification of machines and "thingness" reaches a first culmination in a series of pictures known as the *Objets dans l'espace* (figs. 380, 381). These works, in which Léger elevates the ordinary objects of technical civilization to the realm of sacred emblems through their isolated, gigantically enlarged representation, can be seen in retrospect as the link between the naive art of "the customs agent," Henri Rousseau, and the later enunciations of American Pop Art. We encounter a tendency similar to Léger's in the Americans Davis, Murphy, and Demuth (figs. **354**, 355, 378).

Second row of pictures: Parallel to this bold realism with a faith in progress, there develops within the realistic art of the time a nearly opposite tendency that proceeds from a naive concept of reality derived from Italian 14th century art and the enchanted world of Rousseau (figs. 306, 311). Its seminal mediating figure is the Greek-Italian artist Giorgio de Chirico.

In his early Parisian works, like the famous *Piazze d'Italia* (fig. **314**), De Chirico combines Rousseau's magic experience of things with the visionary Symbolism of Böcklin (fig. 48) and Kubin (fig. 122). A sense of danger and wonder fills the enchanted silence of these large, deserted squares, across which tall monuments,

towers, larger-than-life objects, or isolated people cast their long shadows; inanimate things acquire an unprecedented autonomy and confront human beings in a new and magical form, as something never experienced before (figs. 307, 308, 309, 314). Here, for the first time, we encounter a pictorial vision in which the familiar things of everyday life are shrouded in a mysterious reality that was later to be called surreal.

As the most important forerunner to Surrealism, De Chirico is also represented in the third, symbolist row of pictures.

De Chirico's world consists of artifacts imbued with a menacing inner life. It finds intense representation in the image of the "manechino," the arrangement of wooden figures that appear in every conceivable form in his work (fig. 336) and later also in the paintings of his colleagues Carlo Carrà and Giorgio Morandi (figs. 328, 330–332). This ambiguity between animate and inanimate, which appears at the same time in Marcel Duchamp's anthropomorphic machines (fig. 317), is one of the most conspicuous features of Pittura Metafisica, the school of metaphysical painting founded by De Chirico. After Futurism, it represents the most important Italian contribution to Modernism.

In 1925, the Mannheim Kunsthalle presents a number of German artists in an exhibition entitled *Neue Sachlichkeit* (the New Objectivity), showcasing the attempt to impress the new style of painting into the service of cultural criticism, world betterment, and sexual liberation (figs. 357, 359, **385**). The new realism spreads to other countries. Among its most important exponents are Picasso (fig. 334), who even during his late Cubist phase had begun to paint in both symbolist and realist styles before joining the Surrealist camp (figs. 393, 394, 422–425), and the American Edward Hopper, whose work erects a deeply distressing monument to the isolation and alienation of the modern urban individual (figs. **388**, 417, 418).

The Symbolist Development
From Magical Realism to figurative Surrealism

The two tendencies toward a new figuration, the realistic and the symbolist, show a number of important common elements. The first examples in the second (realistic) and the third (symbolist) row of pictures on the following pages are almost indistinguishable; both begin with the same artists, Rousseau, De Chirico and Chagall, and first diverge starting in 1920.

■ *Third row of pictures:* The Russian painter Marc Chagall (fig. **338**) combines Fauvist and Cubist style elements into the self-willed, unmistakable pictorial idiom

385. Christian Schad: *Girlfriends,* 1928. Oil on canvas, 109.5 x 80 cm

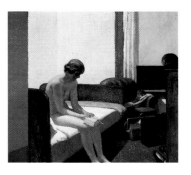

388. Edward Hopper: *Hotel Room,* 1931. Oil on canvas, 152.4 x 165.7 cm

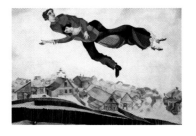

338. Marc Chagall: *Above the City,* 1917/18. Oil on canvas, 114 x 198 cm

[31] See Bocola, 1999, pp. 333–360.

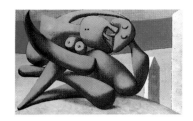

394. Pablo Picasso: *Figures at the Sea,* 1931. Oil on canvas, 130 x 195 cm

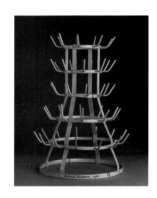

320. Marcel Duchamp: *Bottlerack (Bottle Dryer),* 1914 (1964). Readymade, bottle dryer of galvanized iron, height 64.2 cm

375. Max Ernst: *The Wavering Woman,* 1923. Oil on canvas, 130.5 x 97.5 cm

32 Stauffer, 1983, p. 215.

used in pictures that in their magic aura recall Rousseau and elevate motifs from the Jewish world of his hometown of Vitebsk to a level of universal meaning (figs. 310, 312, 313, 315, 335, 338).

This "surreal realism" also marks De Chirico's early work, and we can see it during the same period in works by Miró and Picasso (figs. 337, 339, 341, 368). These artists no longer seek reflections of their own experience in the outer world but within themselves, in their own artistic feeling, in the stimulus of inner drives and the expressions of fantasy. Starting in 1925, the two Spaniards achieve an abstract mode of painting that symbolistically alienates from the object, opening completely new horizons for the representational tendency of Modernism (figs. 369, 392, 393, **394**, 397). We encounter a sculptural articulation of this stylistic approach in the Surrealist early works of Alberto Giacometti (figs. 395, 396).

■ *Fourth row of pictures:* This series begins with Marcel Duchamp, whom André Breton called the most intelligent artist of the 20th century. After his Cubist-inspired *Nu descendant un escalier* (*Nude Descending a Staircase,* fig. 302), Duchamp creates a series of pictures in which mechanical elements and organic shapes are combined to form what seem like transparent, psycho-biological human machines (fig. 317). In 1913 he constructs a peculiar object by bolting a bicycle fork, complete with wheel, upside down on a stool (fig. 318). When he sets up this *Bicycle Wheel* in his studio, his interest in it is merely playful, expressing his readiness to embrace everything new and untried. But in the following year, when he buys a galvanized cast-iron bottle dryer in a Parisian department store and hangs it from the ceiling of his studio, he signs it and thus declares it to be a work of art (fig. **320**). This gesture marks a watershed in the artistic development of Modernism; through its regular repetition (the bottle dryer is followed by a snow shovel, an iron comb, a typewriter cover, a hat rack and a urinal), Duchamp creates a new kind of art work, for which he coins the term readymade.

The readymade contradicts all traditional understandings of art and the expectation that it should give form and expression to a universal truth and thus meaning to life. Duchamp negates the traditional question of meaning; instead of an answer he presents a thing, a functional object. While Duchamp's provocative object seems to refer to nothing but itself, it does point to a quality that is new and completely unexpected in a work of art – the absence of meaning – and hence to a fundamental experience of our era. As he puts it in an interview: "*Art is not what we see; it is in the gaps.*"[32] And it is the viewer who must fill them in. Without the viewer's creative participation, the work remains fragmentary; only the viewer can complete it.

Following Duchamp, Picabia and Man Ray also discover the attraction and suggestive potential of absurdity. With their distanced and sober reproductions of

imaginary or real technical artifacts they initiate the art of Dadaism (figs. 343–346), which reaches its high point in the collages of Ernst and Schwitters.

This international movement originated in Zurich at the Cabaret Voltaire founded in 1916 by radical opponents of the First World War, writers and artists whose aim was to fight the bourgeois values that they considered responsible for the on-going war. The Dadaists pledged themselves to the irrational and the absurd. This spirit found a visual, artistic formulation only once Francis Picabia arrived from Barcelona and started to propagate the ideas of Marcel Duchamp in Zurich. Only then did a Dadaist art begin to develop, in Zurich, Paris and Berlin, working with the tools of graphic and photographic montage and with objects and material assemblages (figs. 347, 348, 370–373).

Dada's heyday was of short duration. In 1924 André Breton, a member of the Paris Dada movement, declared a new artistic ideology with his Surrealist Manifesto. In opposition to the rational worldview of the bourgeoisie he espoused a completely different inner world of imagination and fantasy, drives and the unconscious, and called upon artists to give form and expression to this higher, surrealist reality. In his view, the first and only goal of art was to expose the irrational, the wonderful and fantastic.[33]

Under the impression of De Chirico's early work, Max Ernst, René Magritte, Yves Tanguy, and Salvador Dalí develop figurative Surrealism. In their paintings they depict with almost photographic realism a fantastic, unreal world, using the illusionistic painting technique of the 19th century (fig. **402**). Dalí tellingly describes his works as photographs of dreams. The defining quality of Surrealist iconography is in the ambiguity between animate and inanimate that we already saw in De Chirico's work (figs. 398–404).

Employing a principle related to collage, a number of Surrealist artists combine the most varied and contradictory objects and materials, including body parts or limbs from dolls and mannequins, into puzzling constructions for which they coin the term "Surrealist object." The most concise formulation of this aesthetic is Lautréamont's famous statement, adopted by the Surrealists as their motto: "*As beautiful as the chance encounter of a sewing machine and an umbrella on a dissecting table*" (figs. **426**, 427, 430).

402. Salvador Dalí: *The Persistence of Memory,* 1931. Oil on canvas, 24 x 33 cm

426. Meret Oppenheim: *Fur Cup,* 1936. Coffee cup covered in fur, saucer, spoon, height 7.3 cm

[33] See my discussion of Surrealist painting and the artistic principle of psychic automatism in Bocola, 1999, pp. 341–360.

The Way to a New Figuration
1905–1945

At the same time as Mondrian and Kandinsky complete their pioneering moves to a nonfigurative art, a series of artists appear to relativize their achievements by charging the object of art with meaning in a completely new, unexpected and unsettling way. They thereby initiate the development to a new figuration, which is carried by both the realistic tendency and the symbolist tendency.

The realistic development
is documented here in two rows of pictures.
The first leads from Futurism (Severini, Balla) to figurative or emblematic realism (Léger, Murphy et al.).

The second leads from the painting of Rousseau and the Pittura Metafisica to magical realism and *Neue Sachlichkeit.*

The symbolist development
is also documented here in two rows of pictures.
The third row leads from Rousseau and Chagall to the magical realism of Miró and Picasso and the abstract Surrealism of Miró, Picasso, Klee and Giacometti.

The fourth row leads from Duchamp and Dadaism in America and Europe (Picabia, Ernst, Hausmann) to figurative Surrealism as represented by Ernst, Magritte, Dalí and Tanguy.

Given the relationship between magical realism, *Neue Sachlichkeit* and Surrealism, artists like Rousseau, De Chirico and Dalí appear both in the second and the third rows of pictures.

realistic

301. Léger, 1910/11

realistic

306. Rousseau, 1909

symbolist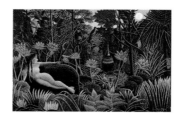

311. Rousseau, 1910

symbolist

316. Duchamp, 1911

302. Duchamp, 1912 303. Severini, 1912 304. Balla, 1913 305. Gris, 1914

307. De Chirico, 1912 308. De Chirico, 1913 309. De Chirico, 1913 310. Chagall, 1914

312. Chagall, 1911 313. Chagall, 1911/12 314. De Chirico, 1914 315. Chagall, 1914

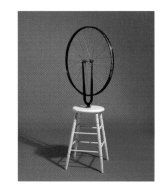
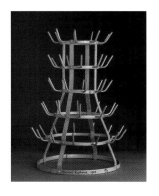

317. Duchamp, 1912 318. Duchamp, 1913 320. Duchamp, 1914

realistic ▶

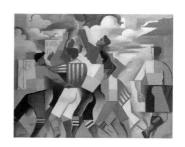

321. Malevich, 1914 322. Depero, 1917 323. Lhote, 1917

realistic ▶

328. Carrà, 1916 329. Modigliani, 1915 330. Carrà, 1917

symbolist ▶

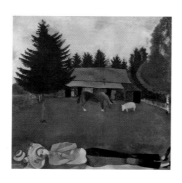

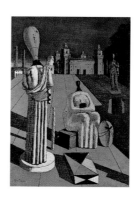

335. Chagall, 1915 336. De Chirico, 1916 337. Miró, 1917

symbolist ▶

342. Duchamp, 1914 343. Picabia, 1915 344. Ray, 1916

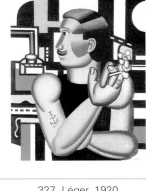

324. Léger, 1917

326. Puni, 1919

327. Léger, 1920

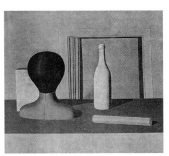

331. Carrà, 1917

332. Morandi, 1918

333. Morandi, 1919

334. Picasso, 1919

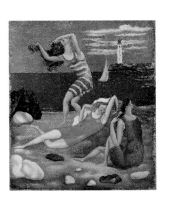

338. Chagall, 1914–1918

339. Picasso, 1918

341. Miró, 1919

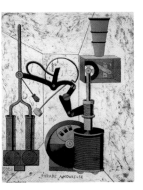

345. Picabia, 1917

346. Picabia, 1918

347. Duchamp, 1919

348. Hausmann, 1919

realistic ▶

349. Rodchenko, 1919/20

350. Le Corbusier, 1919

realistic ▶

356. Morandi, 1920

357. Grosz, 1920

symbolist ▶

363. Klee, 1919

364. Miró, 1920/21

symbolist ▶

370. Ernst, 1920

371. Hausmann, 1920

372. Höch, 1919/20

352. Léger, 1921 353. Balla, 1923 354. Davis, 1924 355. Murphy, 1924

359. Dix, 1922 360. Beckmann, 1923 361. Casorati, 1924 362. Kanoldt, 1924

367. Klee, 1924 368. Miró, 1924 369. Miró, 1924/25

373. Schwitters, 1921 374. Duchamp, 1915–1923 375. Ernst, 1923

realistic ▶

377. Léger, 1927 378. Demuth, 1928 379. Diulgheroff, 1928

realistic ▶

384. O'Keeffe, 1926 385. Schad, 1928

symbolist ▶

391. Van den Berghe, 1927 392. Miró, 1928 393. Picasso, 1930

symbolist ▶

398. Tanguy, 1927 399. Magritte, 1928 400. Magritte, 1929

380. Léger, 1930

381. Léger, 1930

382. Schwitters, 1930

383. Malevich, 1928–1932

387. Sheeler, 1931

388. Hopper, 1931

390. Balthus, 1933

394. Picasso, 1931

395. Giacometti, 1931

396. Giacometti, 1932

397. Miró, 1933

401. Tanguy, 1930

402. Dalí, 1931

403. Magritte, 1933

404. Ernst, 1934

realistic ▶

405. Léger, 1935 406. Schwitters, 1936/37

realistic ▶

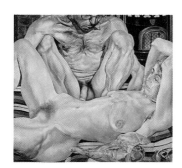

412. Dalí, 1935 413. Spencer, 1936 414. Crawford, 1937

symbolist ▶

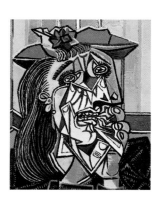

419. Wiemken, 1934 420. Picasso, 1937 421. Klee, 1939

symbolist ▶

426. Oppenheim, 1936 427. Jean, 1936 428. Dalí, 1936/37

408. Léger, 1935–1939

409. Léger, 1941

411. Léger, 1945

415. Balthus, 1939

416. Morandi, 1941

417. Hopper, 1942

418. Hopper, 1944

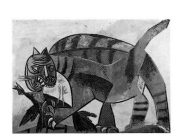

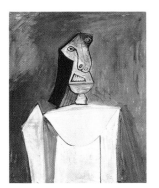

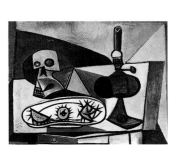

422. Picasso, 1939

424. Picasso, 1943

425. Picasso, 1946

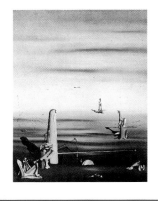

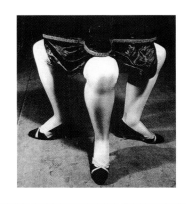

429. Tanguy, 1937

430. Seligmann, 1938

432. Cornell, 1945

Josef Albers 1888–1976
Hans Arp 1886–1966
Giacomo Balla 1871–1958
Balthus (Balthazar Klossowski
de Rola) 1908
Willi Baumeister 1889–1955
Max Beckmann 1884–1950
Frits van den Berghe 1883–1939
Max Bill 1908–1994
Walter Bodmer 1903–1973
Constantin Brancusi 1876–1957
Georges Braque 1882–1963
Alexander Calder 1898–1976
Carlo Carrà 1881–1966
Felice Casorati 1886–1963
Marc Chagall 1887–1985
Ilia Grigorievich Chashnik 1902–1929
Giorgio de Chirico 1888–1978
Joseph Cornell 1903–1972
Ralston Crawford 1906–1978
Salvador Dalí 1904–1989
Stuart Davis 1894–1964
Robert Delaunay 1885–1941
Charles Demuth 1883–1935
Fortunato Depero 1892–1960
André Derain 1880–1954
Walter Dexel 1890–1973
Nicola Diulgheroff 1901–1982
Otto Dix 1891–1969
Theo van Doesburg 1883–1931
César Domela 1900–1992
Marcel Duchamp 1887–1968
Theo Eble 1899–1974
Max Ernst 1891–1976
Lucio Fontana 1899–1968
Naum Gabo 1890–1977
Alberto Giacometti 1901–1966
Fritz Glarner 1899–1972
Julio González 1876–1942
Arshile Gorky 1905–1948
Juan Gris 1887–1927
George Grosz 1893–1959
Hans Hartung 1904–1989
Raoul Hausmann 1886–1971
Jean Hélion 1904–1987
Hannah Höch 1889–1978
Edward Hopper 1882–1967
Boris Vladimirovich Ioganson
1893–1973
Alexej von Jawlensky 1864–1941
Marcel Jean 1900
Wassily Kandinsky 1866–1944
Alexander Kanoldt 1881–1939
Ernst Ludwig Kirchner 1880–1938
Paul Klee 1879–1940
Ivan Vassilievich Kliun 1873–1942

František Kupka 1871–1957
Henri Laurens 1885–1954
Bart van der Leck 1876–1958
Le Corbusier (Charles Edouard
Jeanneret) 1887–1965
Fernand Léger 1881–1955
André Lhote 1885–1962
Richard Paul Lohse 1902–1988
El Lissitzky 1890–1941
René Magritte 1898–1967
Kazimir Malevich 1878–1935
Franz Marc 1880–1916
André Masson 1896–1987
Henri Matisse 1869–1954
Roberto Matta Echaurren 1911
Joan Miró 1893–1983
Amedeo Modigliani 1884–1920
László Moholy-Nagy 1895–1946
Piet Mondrian 1872–1944
Giorgio Morandi 1890–1964
Gerald Murphy 1888–1964
Emil Nolde 1867–1956
Georgia O'Keeffe 1887–1986
Meret Oppenheim 1913–1985
Francis Picabia 1879–1953
Pablo Picasso 1881–1973
Jackson Pollock 1912–1956
Liubov Popova 1889–1924
Ivan Puni 1892–1956
Man Ray 1890–1976
Kliment Redko 1897–1956
Aleksandr Rodchenko 1891–1956
Olga Rosanova 1886–1918
Mark Rothko 1903–1970
Henri Rousseau 1844–1910
Christian Schad 1894–1982
Kurt Schwitters 1887–1948
Kurt Seligmann 1900–1962
Gino Severini 1883–1966
Charles Sheeler 1883–1965
Mario Sironi 1885–1961
Stanley Spencer 1891–1959
Sophie Taeuber-Arp 1889–1943
Yves Tanguy 1900–1955
Vladimir Tatlin 1885–1953
Paule Vézelay (Paule Watson-
Williams) 1892–1984
Friedrich Vordemberge-Gildewart
1899–1962
Walter Kurt Wiemken 1907–1940

1945 – 1980
Triumph and Consummation

1945–1980. Triumph and Consummation

Before we can follow the subsequent development of Modernism, we must turn to one of the darkest chapters of European history: the rise and fall of Adolf Hitler, the terror of National Socialism, and the Second World War.[34]

The worldview and self-concept of the modernist era, which had already found its artistic, scientific, political and social form and expression before the First World War, began during the interwar period (documented on pages 62 to 83) to spread throughout the Western world. The social and political models of the modernist idea – democracy, political equality of the sexes, separation of church and state, the right to education and information, and the protection of the private sphere – came hand-in-hand with hitherto unheard of claims to self-determination. The fulfillment of these claims, however, was perceived among broad strata of society not only as an enrichment but as a threat. The intellectual attitude of Modernism had not simply reduced dependence and social repression and helped raise the standard of living; it also destroyed the worldview and mental structures that until then provided protection and stability. The prevailing mood of the new era was marked by a general sense of insecurity.

1012. Hitler at a military parade on the Zeppelin Airfield near Nuremberg, 1937

This insecurity could be tolerated without objection only for as long as it shone in an optimistic light, i.e. for as long as the promises of the newly gained rights and freedoms could push the associated fears into the background. With the outbreak and mounting intensity of the material and spiritual crises of the postwar period, that was no longer the case. The ambiguity of the modernist era – the ineradicable link between freedom and insecurity – was increasingly perceived as intolerable. In nearly all European countries, radical nationalist and anti-democratic movements rose up with new offers of absolute certainties and promises that the life of each person and of the nation could be put back on solid spiritual and economic foundations. The declared goal of these movements, which we nowadays describe as fascist, was the creation of a totalitarian state. The most extreme and fateful manifestation of this attitude of mind (as a political revolt against the modernist idea) was found in German National Socialism.

The core of National Socialist ideology lay in Hitler's Social Darwinist racial doctrine. According to that, humanity consists of superior and inferior races; the superior have the right to subjugate the inferior and use them in the service of their own goals and purposes. In this scheme, the best and most valuable race is that of the German peoples, the "Aryan" race. The idealization of the Aryan went hand-in-hand with a fanatic anti-Semitism that in the end led to a systematic extermination of the European Jews.

The Jew functioned as a stand-in for all people, forces or institutions that directly or indirectly questioned Hitler's inflated self-image and claims to power. To Hitler, democracy and the League of Nations, pacifism, Marxism and modernist art were

[34] See Bocola, 1999, pp. 369–389.

1013. Guide to the "Degenerate Art" exhibition, Berlin, 1937. Cover page, 21 x 14.8 cm

all Jewish inventions; the Soviet Union, "*international finance capital,*" the German Revolution of 1918, the Weimar Republic and the Treaty of Versailles were all works of "*international Judaism.*" It is pointless to refute these nonsensical claims. The common denominator that connects all of these manifestations branded as "Jewish" is the mental attitude or worldview of which they were an expression. Hitler's image of the enemy – "*international Judaism*" – has a paradigmatic significance. It stood for the spirit of Modernism.

With Hitler's seizure of power in Germany in January 1933 came the legal disenfranchisement and the material persecution of the Jews. At the same time, cultural life was to be "*freed of all Jewish influence*" (literally: "*dejudaize*"), protected from the subversive influence of "*international*" thinking, and regained as a province of "*Aryan genius.*" Accordingly the Bauhaus was shut down on April 11th, 1933, followed by the infamous book burnings on May 10th and, finally, the "*purging*" of the museums and galleries.[35]

Hitler's foreign policy was marked by the same ruthless determination that he had displayed in the pursuit of his domestic goals. After the annexation of Austria, the bloodless occupation of the Sudetenland and subsequent absorption of the rest of Czechoslovakia, German armed forces overran the Polish borders on September 1st, 1939, setting off the most destructive war in history, which ended after five and a half years with the utter defeat of the Axis powers.

The repercussions of the Second World War on cultural history were comparable to those of the French Revolution, this time affecting not just Europe but the whole world. Henceforth the world was split into two blocs divided by a boundary running right through the middle of a devastated Europe that had ceded its political, economic and intellectual hegemony to the new world powers – to the United States and the Soviet Union. The sense of self that had once sustained the Old World lay buried beneath the rubble.

The extent of the destruction and horror unleashed upon the world by a country as cultured as Germany – with its history of great thinkers, poets and musicians – the discovery of the concentration camps and the accounts of the systematic murder of six million Jews, the photographs of prisoners, the mass graves, the gas chambers and crematoria of Auschwitz, Dachau and Treblinka united the civilized world in its abhorrence of Nazi terror and shattered any remaining illusions about the intellectual and moral supremacy of Western civilization.

All progressive, liberal and anti-bourgeois tendencies, in spite of the often unbridgeable gulfs among them, were thus cast in a new light and gained newfound respectability and vindication. With his failed attempts at restoration, with his insane extreme of political absolutism, Hitler ultimately helped to bring about the tri-

[35] Backed by an official decree "against Negro culture, for the German people," a so-called Fighting Alliance for German Culture began confiscating from public collections the works of modernist artists classified as "*culturally Bolshevik, degenerate or subversive.*" The works were exposed to public derision in veritable "exhibitions of shame." More than 600 works were put on admonitory display in the infamous exhibition of "Degenerate Art." The traveling show offered a representative cross-section of classical modernist art and was intended to demonstrate the dangers of a development steered by "*Jewish and Bolshevik*" agents and its inevitable culmination in "*perfected insanity.*"

umph of precisely those ideas and principles that he had so bitterly opposed. Internationalism, social pluralism, democracy and communism became the dominant factors in the politics of the postwar world. To secure world peace and advance international cooperation, 52 governments convened on October 24, 1945 to adopt the charter of the United Nations, which among other goals purposed the protection of human rights and basic freedoms (fig. **1014**).

1014. Signing of the Charter of the United Nations in San Francisco, CA, on June 26, 1945

This reappraisal redefined the intellectual life of Western democracies, in particular influencing their artistic consciousness. Much of the old cultural context came to be equated with a Europe of power-hungry nation states, and with traditions and values that were held responsible for the catastrophe just endured. Modernist art was not tarred with the same brush; it represented one of the few achievements of Western culture that could still be idealized. Its condemnation by the Nazis and their persecution of its exponents made it into a symbol of intellectual resistance, of the integrity and continuity of a liberal European consciousness. In the United States and the countries of western Europe, the great masters of Modernism were now presented to a broader public in individual and major group exhibitions. The outsiders and the revolutionaries of the pre-war era became established figures.

Even as they celebrated their belated triumph, even as some of them – Matisse and Giacometti spring to mind – actually created their most important works, the artists of a war-scarred Europe lacked the will and strength to build on previous artistic developments in a creative and innovative way. That fell instead to the relatively unsullied and unburdened American artists, who had recently discovered modernist art for themselves, and who sought to create their own, truly American works that would rank alongside those of their much admired predecessors.

Our documentation of this development, in this chapter covering the years from 1945 to 1980, is once again divided according to the four basic attitudes with which the reader should by now be familiar: the realistic, the structural, the romantic and the symbolist. But so great and diverse is the artistic production within each of the basic tendencies that we shall employ four rows of pictures for each, thus devoting the entire page of the timeline and a full section to one tendency at a time.

We begin with the romantic development.

1945–1980. Triumph and Consummation

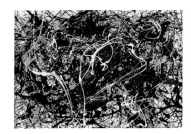

453. Jackson Pollock: *Number 33,* 1949. Enamel and aluminium paint on gesso on paper, mounted on fiberboard, 57.1 x 78.7 cm

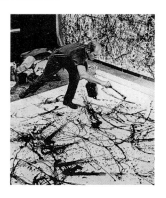

1015. *Jackson Pollock at work.* Photo by Hans Namuth, 1950.
Namuth recorded Pollock working in 1950 in a film and now famous series of photo stills. These show the directness, consistency and extreme radicality with which the American realizes pictorially the Surrealist postulate of psychic automatism.

509. Willem de Kooning: *Rosy-fingered Dawn at Louse Point,* 1963. Oil on canvas, 194 x 222 cm

The Romantic Development
Mystical fusion through ecstasy and meditation

In the altered cultural climate of the postwar era, the United States steps onto the stage of international art for the first time. Young and powerful, progressive and democratic, the center of modern technology and industry, melting pot of enormous ethnic diversity and home to the newest and most popular forms of art – jazz and film – the United States, unscathed by war, embodies like no other country the hopes and ideals of the postwar era.

Before and during the war, countless representatives of Europe's intellectual elite emigrated to the United States to escape Nazi persecution. European scientists, philosophers and psychoanalysts, poets, musicians and filmmakers, artists and architects exercised an enormous influence on American intellectual life. László Moholy-Nagy founded the New Bauhaus in Chicago. Josef Albers taught at Black Mountain College in North Carolina, Hans Hofmann at the Art Students League in New York. The second great wave of European emigrants arrived in the U. S. soon after the outbreak of the war. Among them were Chagall, Lipchitz, Léger and Mondrian, as well as the Surrealists Matta, Tanguy, Ernst, Masson and Breton. The new American painting owes its initial, crucial impulse to them (figs. 294–300).[36]

First row of pictures: The first American really to break with the European tradition in his painting is Jackson Pollock. Pollock makes the breakthrough to his own formal syntax shortly after the war, developing a working method that corresponds more to a Dionysian dance than to conventional craftsmanship (fig. **1015**). He works with liquid paints and industrial lacquers, or silver and aluminum emulsions that he drips from a brush or swings rhythmically from a perforated can over a canvas on the floor. The resulting works are huge canvases covered in a dense, polychromatic network of intertwined splashes, explosive blotches and febrile arabesques, with neither top nor bottom, drawing nor background, so that the image seems to continue endlessly beyond the edge of the picture (hence the descriptive term "all-over painting," see fig. **453**).

These rhythmic, labyrinthine drip paintings appear to have been created in an ecstasy, and they are the first examples of a movement in art for which the American critic Clement Greenberg coined the term Abstract Expressionism. Today, the term is also used to refer to parallel European movements that were known at the time as Abstraction Lyrique, Informel or Tachisme.

In America and Europe alike, we can find two distinct directions within Abstract Expressionism: first, a gestural "Action Painting" in which the picture as a whole, as in Pollock's work, bears visible testimony to the impulsive and impromptu

[36] See Bocola, 1999, pp. 391–400.

90

painting process and whose leading exponents in America (aside from Pollock) are Willem de Kooning (figs. 459, **509**, 510), Franz Kline (figs. 456, 485) and Cy Twombly (figs. 458, 481, 512).

■ *Second row of pictures:* In the second current within Abstract Expressionism, large areas of color are juxtaposed without specific form in flat, adjacent fields, expressing a sense of the infinite and ineffable. The most important exponent of what comes to be called Color Field Painting, Rothko, creates in the early 1950s the first of a magnificent series of calmly self-contained pictures bathed in a mysterious light. These establish his worldwide fame (figs. 441, **464**, 489, 520).

Artists like Louis, Noland and Olitski proceed from there to develop a tendency that becomes known as Post Painterly Abstraction. Devoted primarily to the intrinsic value of color, they limit the formal content of their pictures to the sparing use of basic geometric elements, renouncing all traces of painterly style. Whereas Louis operates with soft, fluid swathes of color (fig. 492), Noland and Olitski (figs. 493, 516) apply color in flat, homogeneous areas, or impregnate their canvases with liquid paint to eliminate any evidence of a painter's touch.[37]

■ *Third row of pictures:* In Newman, the mystically contemplative aspect of Abstract Expressionism reaches its apex. Starting in 1948, he reduces his formal message by subdividing a large, uniformly colored canvas by means of a narrow central stripe in a different color. This initiates the development that leads from Post Painterly Abstraction to the structurally oriented Hard Edge painting (figs. 446, 447, 467, 468). The most ascetic exponent of this tendency, Reinhardt, launches in 1954 his series of *Black Paintings,* in which rectangular black formats are structured by barely perceptible strips in the shape of a cross – also in black (fig. 473).

The early 1960s see the introduction of non-rectangular, shaped canvases, with which the outline of a painting becomes a defining compositional factor. Newman, Stella, Noland and many others fit the outward format of their pictures to the composition on the picture plane, eliminating the antinomy of figure and ground, i.e., achieving complete conformity between the content and the form of the picture (figs. 523, 524, **525**, 528, etc.).

■ *Fourth row of pictures:* Abstract Expressionism spreads to Europe in the form of Tachisme, Informel, and Lyrical Abstraction. Artists like Appel, Jorn, Soulages, Schaffner and Schumacher create a European variant of American Action painting.[38]

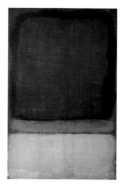

464. Mark Rothko: *Untitled,* 1951. Oil on canvas, 236.2 x 144.8 cm

525. Barnett Newman: *Jericho,* 1968/69. Acrylic on canvas, 305 x 290 cm

[37] Alongside the Americans, this series also includes Matisse and Miró, who in their late work followed related tendencies.

[38] At first glance, the calm and self-contained canvases of Color Field Painting and Post Painterly Abstraction seem to stand in stark contrast to the frenzied world of American and European Action Painting; and yet artists of both tendencies broadly concur in their ideational positions. They all proceed from emblematic Surrealism, in an attempt to apply it on a cosmic level. Whereas their Surrealist precursors were obsessed with the magic experience of things and the ambiguity between animate and inanimate, their work explores the two different forms of mystical experience: the ecstasy of intoxication and the ecstasy of contemplation.

1945–1980. Triumph and Consummation
The Romantic Development

The romantic development of the post-Second World War period is influenced by Abstract Expressionism, an artistic tendency that proceeds from figurative Surrealism and is depicted here in four rows of pictures.

The first row documents American Action Painting, in which the picture as a whole bears visible witness to an impulsive and improvised process of painting.

The second row shows the influence of Color Field Painting and Post Painterly Abstraction.
These artists are mainly interested in the intrinsic expressive value of color, and therefore restrict the formal statement of their pictures to the sparing use of a few basic elements.
Matisse and Miró follow related tendencies in their late work and are therefore included in our documentation of this primarily American style of painting.

In the third row we see the transition from the painting of Barnett Newman – who brings the mystic-contemplative current within Abstract Expressionism to its apex – to American Hard Edge Painting and the shaped canvas.

The fourth row documents the European variants of Action Painting, which are known variably as Abstraction Lyrique, Tachisme and Informel.

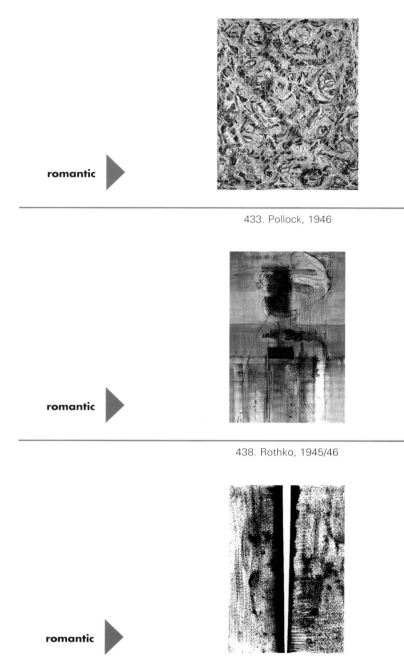

romantic ▶

433. Pollock, 1946

romantic ▶

438. Rothko, 1945/46

romantic ▶

443. Newman, 1946

romantic ▶

448. Vedova, 1945

434. Gorky, 1947 435. Tomlin, 1947 436. De Kooning, 1948 437. Pollock, 1948

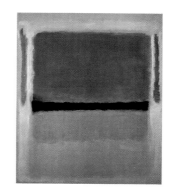

439. Rothko, 1947 440. Francis, 1948 441. Rothko, 1949 442. Gottlieb, 1949/50

445. Newman, 1948 446. Newman, 1949 447. Newman, 1949

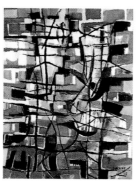

449. Wols, 1946 450. Bazaine, 1947 452. Hartung, 1949

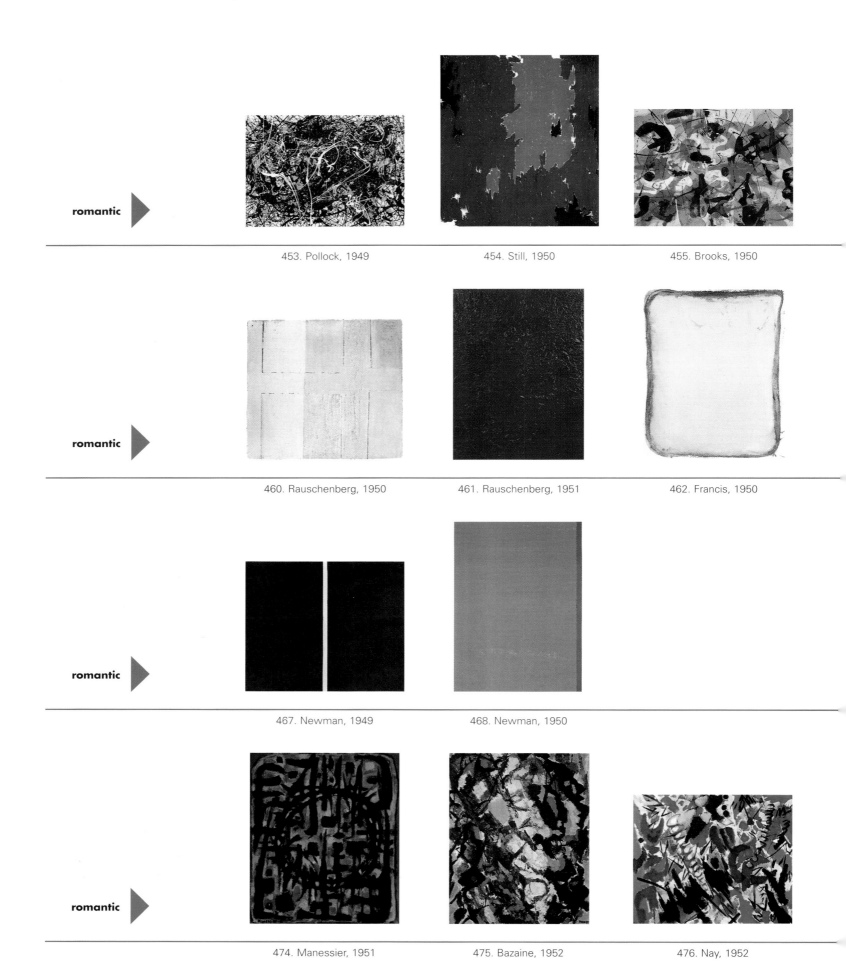

romantic ▶

453. Pollock, 1949 454. Still, 1950 455. Brooks, 1950

romantic ▶

460. Rauschenberg, 1950 461. Rauschenberg, 1951 462. Francis, 1950

romantic ▶

467. Newman, 1949 468. Newman, 1950

romantic ▶

474. Manessier, 1951 475. Bazaine, 1952 476. Nay, 1952

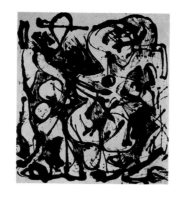

456. Kline, 1950 457. Pollock, 1951 458. De Kooning, 1953 459. Twombly, 1954

463. Matisse, 1951 464. Rothko, 1951 465. Francis, 1952 466. Motherwell, 1953

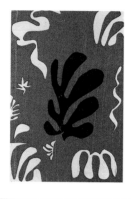
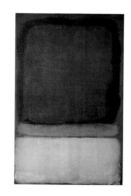

470. Kelly, 1952 471. Reinhardt, 1952 472. Newman, 1952 473. Reinhardt, 1954

477. De Staël, 1952 478. Soulages, 1953 479. Mathieu, 1954 480. Riopelle, 1954

1945–1980. Triumph and Consummation
The Romantic Development

romantic ▶

481. Twombly, 1955 482. Guston, 1957 483. Tobey, 1957

romantic ▶

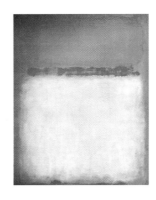

488. Matisse, 1953 489. Rothko, 1955 490. Noland, 1958

romantic ▶

496. Newman, 1954

romantic ▶

502. Fautrier, 1955 503. Hartung, 1956 504. Jorn, 1957

484. Still, 1957 485. Kline, 1957 486. Francis, 1958/59 487. Hofmann, 1961

491. Rothko, 1959 492. Louis, 1959/60 493. Noland, 1960 494. Miró, 1961

499. Newman, 1960 500. Stella, 1960 501. Ryman, 1960

505. Schumacher, 1958 506. Schaffner, 1959 507. Saura, 1959 508. Appel, 1962

romantic ▶

509. De Kooning, 1963 510. De Kooning, 1964

romantic ▶

516. Olitski, 1965 517. Frankenthaler, 1966 518. Diebenkorn, 1968

romantic ▶

523. Stella, 1964 524. Stella, 1968 525. Newman, 1968/69

romantic ▶

530. Nay, 1962 531. Vedova, 1962/63 532. Sonderborg, 1965

512. Twombly, 1968 513. Smith, 1968/69 515. Johns, 1978

519. Motherwell, 1969 520. Rothko, 1968 521. Haubensak, 1970 522. Ryman, 1980

526. Marden, 1969 527. Newman, 1969 528. Stella, 1972 529. Stella, 1978

533. Schaffner, 1966 535. Schumacher, 1973/74 536. Disler, 1978

1945–1980. Triumph and Consummation

1016. Robert Rauschenberg: *Collection,* 1954. Combine painting: oil, paper, cloth, newspaper, printed matter, wood, metal and mirror on three wood panels, 203.2 x 243.8 x 8.9 cm

591. Robert Rauschenberg: *Retroactive II,* 1964. Oil, silk screen on canvas, 213 x 152 cm

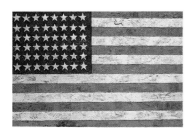

538. Jasper Johns: *Flag,* 1954/55. Encaustic, oil and collage on fabric mounted on plywood (three panels), 107.3 x 154 cm

³⁹ See Bocola, 1999, pp. 401–456.

The Realistic Development
The medium is the message

Even as Abstract Expressionism is celebrated internationally, two young artists in New York – Jasper Johns and Robert Rauschenberg – effect a radical break with nonfigurative art by turning their attention to the visible reality of everyday urban life. In their wake, modernist art finds its way to a new realism with the emergence of American Pop Art and its British and Continental variations.³⁹

The realistic art of the postwar period is devoted to the visible reality of urban consumer society, the appearance of which is shaped by industrial production, design, advertising and the mass media. Johns and Rauschenberg, like the exponents of Pop Art, are not interested in the "meaning" of this reality, but in the creative and psychological conditions of its transmission through the media. Adopting the iconography of the media as their own, they also appropriate the fundamental creative condition of the media: reproducibility. The defining stylistic technique of the new realism is the quote.

First row of pictures: At the time of Johns's and Rauschenberg's first meeting, Rauschenberg is working on his *Combine Paintings.* These incorporate diverse fragments of everyday life such as torn posters, clippings from newspapers and magazines, photographs, labels, street signs and panels, three-dimensional objects like kettles, doors and car tires, and soft objects like shoes and hats. He mounts his innumerable objets trouvés into large-scale assemblages – and then covers them with cheap industrial paints, entirely or in part, often in the most brutal manner and seemingly without any aesthetic intention whatsoever (figs. 537, 539, 560, **1016**).

Starting in 1960, Rauschenberg employs silk-screen printing, which allows him to enlarge and manipulate the colors of photographs from newspapers and magazines. Using this combination of printing and painting techniques, he devises a new type of montage picture in which fragments overlap and interact: text, reproductions of paintings, technical diagrams, photographs of people, machinery, vehicles and buildings are combined with painterly gestures, splashes and daubs of color (figs. 587, **591**).

Johns, Rauschenberg's junior by five years, lives in the same building. In 1954, he paints his *Flag* – the now famous picture of the American flag with which the realistic development of Modernism enters a new phase (fig. **538**). In this work, Johns does not portray a "real" flag hanging on a mast or fluttering in the wind; in-

stead he transposes the flat pattern of the Stars and Stripes directly onto the canvas, but making sure that the pattern of the flag corresponds exactly to the format of the painting. Instead of depicting the flag, he is making a picture that in effect itself becomes a flag. He takes a similar approach with the prototypes on which his subsequent paintings are based. Starting in 1956 he also begins integrating three-dimensional objects in his pictures and finally he creates, using casts of real objects, a number of free-standing sculptures (figs. **541**, 558). Instead of showing reality, his works seem to turn into their prototypes, thus imparting insight into the contingency and doubtfulness of every form of reality.

In the course of the 1960s his works become more like the *Combine Paintings* of his friend Rauschenberg (figs. 562, 589, 613). In the 1970s, he creates a set of entirely nonfigurative *Cross-hatchings* (fig. 515 on p. 99). Finally, in the 1980s he turns to a symbolist mode of painting in which considerable scope is given to unfathomable, subjective and autobiographic references (see figs. 939, 960, 961 on pp. 149–151).

The arrival of Jasper Johns and Robert Rauschenberg heralds a crucial turn of events on both sides of the Atlantic. A growing number of young artists discover a new source of inspiration in the iconography of everyday urban life and begin exploring its creative potentials.

From plaster and paper maché, Claes Oldenburg makes rough reproductions of the items offered in the fast food stores and shabby shop windows of his neighborhood (fig. 561). In his later *Soft Sculptures* (figs. 585, **586**), and in his projects for monumental versions of tools and fixtures for display in public spaces (figs. 614, 616, 619), the basic theme of American Pop Art – the perceptive ambiguity of reality – finds some of its most surprising and diverse articulations.

Second row of pictures: Like Jasper Johns, Andy Warhol and Roy Lichtenstein also extract pre-existing and essentially banal models from conventional contexts and reproduce these apparently unaltered. Lichtenstein takes panels from comic books, or illustrations from advertisements and brochures, out of their original context and blows them up into huge formats, thereby confronting the viewer with an image that is familiar and yet never before seen (figs. 564–566, **592**, 593, 596).

Using a simple, rough silk-screen process, Warhol transposes his models onto raw or primed canvas, singly or doubly, by the dozen or even by the hundred, creating multiple variations on each individual subject. Dollar notes, soup cans, Coca-Cola bottles, Marilyn's face, the electric chair and the explosion of the atomic bomb over Bikini are all torn out of context and presented without com-

541. Jasper Johns: *Light Bulb I*, 1958. Sculp-metal, 11.5 x 17.1 x 11.5 cm

586. Claes Oldenburg: *Soft Typewriter*, 1963. Vinyl filled with kapok, Plexiglass, nylon cord, 22.9 x 66 x 69.9 cm

592. Roy Lichtenstein: *Drowning Girl*, 1963. Oil and synthetic polymer on canvas, 171.6 x 169.5 cm

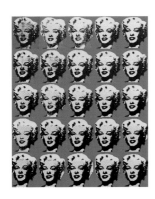

569. Andy Warhol: *Twenty-Five Colored Marilyns*, 1962. Acrylic on canvas, 209 x 170 cm

624. Duane Hanson: *Supermarket Lady*, 1969. Painted fiberglass, polyester and pieces of cloth, shopping cart with product packages, approximately 166 x 70 x 70 cm

628a. Allen Jones: *Desire Me*, 1968. Pencil and ballpen on cartridge paper, plus airbrushed photograph, 96.5 x 41.9 cm

628b. Allen Jones: *Man Pleaser*, 1968. Oil on canvas and retouched photograph mounted on masonite, approximately 96 x 30 cm

mentary – not so much as external and "real" facts but as representatives of the anonymous media-transmitted (second-hand) reality that permeates our consciousness (figs. 567, **569**).

Next to Oldenburg, Lichtenstein and Warhol, the most important representatives of American Pop Art are Jim Dine, Tom Wesselmann, James Rosenquist, Mel Ramos, Robert Indiana and Richard Lindner.

The painting and plastic art of the 1960s and 1970s also give rise to the tendency of Hyperrealism (or Photorealism) with its extreme, naturalistic illusionism. Hyperrealist painters project photographic slides onto the canvas and then carefully reproduce the image in paint, with clinical precision. Pictures created in this way can barely be distinguished from enlargements of color photos; no one fails to be amazed at their technical perfection (fig. 622). Much the same is true of Hyperrealist plastic art, with archetypal figures drawn from everyday situations so true to life that they recall the figures in a wax museum (fig. **624**).

Third row of pictures: The origins of British Pop Art can be traced back to the early 1950s, when a loose association of young artists, architects and designers formed in London as the Independent Group, with the aim of exploring the potentials for mixing the various new media. They organized discussions, lectures, publications and exhibitions.

One of the most important members of this group, Richard Hamilton, does not employ the style of the new media in the manner of Warhol and Lichtenstein, but adopts only certain formal aspects, technical possibilities and real objects of commercial mass culture, using these to compose his own, collage-like pictorial works (figs. 549, 572, 573, 603). Hamilton first takes the step towards Pop Art as we know it in the mid-1960s (fig. 604), but he is fickle to the style and continues his creative experiments in every possible direction.

The first major wave of British Pop Art begins in the early 1960s with a group of young artists who met as students at the Royal College of Art: David Hockney, Allen Jones (figs. 577, 602, **628**, 632), Derek Boshier (fig. 574) and Peter Phillips (figs. 571, 629). Together with Joe Tilson and the younger Patrick Caulfield, they develop an art that reflects the intellectual and social climate of "Swinging London": a booming economy, emancipation from sexual taboos, the drug scene, Mary Quant's fashions, the Beatles and the Rolling Stones, Zen Buddhism and Indian music, cars, television and the ubiquity of the mass media. The works of these artists are more playful and fragmentary than those of their American colleagues. They do not convey the underlying essence of the new reality, only its glittering surface.

Fourth row of pictures: The artistic trend towards reality is not restricted to the Anglo-American world; a corresponding development takes place in Continental Europe, where the French art critic Pierre Restany on October 27th, 1960 founds the Parisian Noveau Réalisme group, with Yves Klein, Jean Tinguely, Martial Raysse, Daniel Spoerri, Arman, Raymond Hains and François Dufrêne among its initial members. They are later joined by César, Jacques Mahé de la Villeglé, Mimmo Rotella and Niki de Saint Phalle.

Their art also reflects the urban consumerist society of the 20th century. But while the Americans confront the stiffened clichés of mass media content, the Nouveau Réalistes in their assemblages prefer concrete, mostly used objects and every variety of garbage. Their material is drawn not from shopping center shelves but from flea markets and junk yards.

The poster-tearing artists Hains, Villeglé, Dufrêne and Rotella remove partially torn or completely tattered posters from walls, mount them on suitable carriers and exhibit them as *Décollages* (figs. 553, 556, 578, 606).

Arman heaps up similar objects, most of them used and worn items (spoons, light bulbs, telephone receivers, coffee pots and the like) into his *Accumulations,* which he presents in glass display cases or in Plexiglass containers (fig. **583**).

Spoerri glues or otherwise affixes found arrangements (such as the remains of a meal, tools left on a table, or a waiter's tips stacked on a tray) onto flat bases, and tips these into the vertical to be hung on the wall as a work of art (fig. **581**).

Tinguely uses scrap-metal and all manner of materials to create completely useless kinetic objects driven by small electric motors, which then perform some absurd, noisy movement (figs. 555, 584).

Christo, who was not a member of the Nouveau Réalisme group, transposes all manner of objects (an armchair, a tailor's dummy, a motorbike or a hobby-horse) by wrapping them in fabric or plastic and tying them up (fig. 610).[40]

Related tendencies appear in Germany. Artists like Polke and Klapheck devise an enigmatic realism that evokes the early Picabia (figs. 611, 612, 635) while Richter uses painterly reproductions of photo stills to confront us with the ambiguity of the real (figs. 607, 634).

583. Arman: *Pile of Watering Pails,* 1961. Enamel pails in Plexiglass case, 83 x 142 x 42 cm

581. Daniel Spoerri: *Kichka's Breakfast,* 1960. Assemblage (found, vertical), 37 x 69 x 64 cm

[40] In 1968, Christo and Jeanne-Claude initiate their series of large-scale projects with the first packaging of a public building, the Kunsthalle in Bern. After a long series of similar works, such as in 1972 with *The Valley Curtain* in Colorado, he packages the Reichstag in Berlin (fig. 873).

1945–1980. Triumph and Consummation

The Realistic Development

The realistic art of the postwar period focuses on the reality of urban consumer society, the exterior of which is shaped by design, advertising and the mass media.

The first row of pictures begins with the early, sometimes three-dimensional works of Jasper Johns and Robert Rauschenberg, as a result of which Modernism discovers a new realism. We follow this development to the *Soft Sculptures* and the large-scale statues of Claes Oldenburg.

The second row of pictures documents the development of American Pop Art, which appropriates the iconography of urban life and the visual forms and techniques of the mass media, mainly by extracting existing, intrinsically banal prototypes from their conventional context and presenting them, isolated and apparently unchanged, as works of art.

The third row of pictures traces British realism from the early works of Paolozzi, Hamilton and Blake to British Pop Art proper, which reflects the intellectual and social climate of "Swinging London."

The fourth row of pictures follows parallel developments in Continental Europe, such as the movement of Nouveau Réalisme, the exponents of which operate mainly with torn posters, used objects and every form of garbage, and the Dada-inspired realistic tendencies in German art.

realistic ▶

537. Rauschenberg, 1955

realistic ▶

542. Davis, 1951

realistic ▶

547. Paolozzi, 1949

realistic ▶

552. Schwitters, 1947

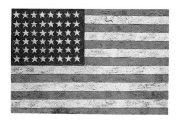

538. Johns, 1954/55 539. Rauschenberg, 1955 540. Johns, 1955 541. Johns, 1958

543. Lindner, 1951 544. Kaprow, 1956 545. Johnson, 1958 546. Warhol, 1960

548. Hamilton, 1954 549. Hamilton, 1956 550. Blake, 1955–1957 551. Hockney, 1960

553. Hains, 1950 555. Tinguely, 1959 556. Villeglé, 1960

The Realistic Development

realistic ▶

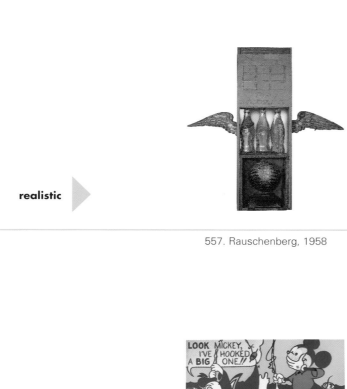

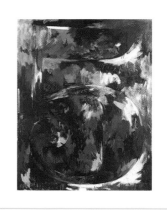

557. Rauschenberg, 1958 558. Johns, 1960 559. Johns, 1960

realistic ▶

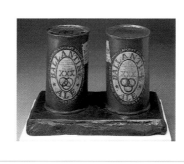

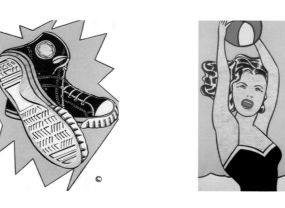

564. Lichtenstein, 1961 565. Lichtenstein, 1961 566. Lichtenstein, 1961

realistic ▶

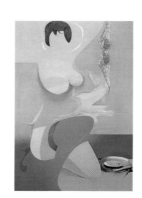

571. Phillips, 1961 572. Hamilton, 1961 573. Hamilton, 1962

realistic ▶

578. Rotella, 1960 580. Saint Phalle, 1960

560. Rauschenberg, 1961 561. Oldenburg, 1961 562. Johns, 1962 563. Dine, 1962

 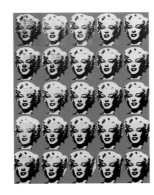

567. Warhol, 1962 568. Warhol, 1962 569. Warhol, 1962 570. Rosenquist, 1962

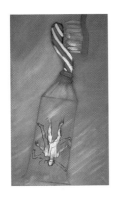

574. Boshier, 1962 576. Paolozzi, 1962 577. Jones, 1962

581. Spoerri, 1960 582. César, 1961 583. Arman, 1961 584. Tinguley, 1962

realistic ▶

585. Oldenburg, 1962

586. Oldenburg, 1963

587. Rauschenberg, 1962

realistic ▶

592. Lichtenstein, 1963

593. Lichtenstein, 1963

594. Wesselmann, 1963

realistic ▶

599. Caulfield, 1963

600. Hockney, 1963

601. Kitaj, 1964

realistic ▶

606. Rotella, 1962

607. Richter, 1962

588. Johns, 1963

589. Johns, 1963/64

591. Rauschenberg, 1964

595. Ramos, 1964

596. Lichtenstein, 1965

597. Wesselmann, 1965

598. Wesselmann, 1965

602. Jones, 1964

603. Hamilton, 1964

604. Hamilton, 1965/66

605. Paolozzi, 1965

609. Hains, 1964

610. Christo, 1965

611. Polke, 1965

612. Klapheck, 1965

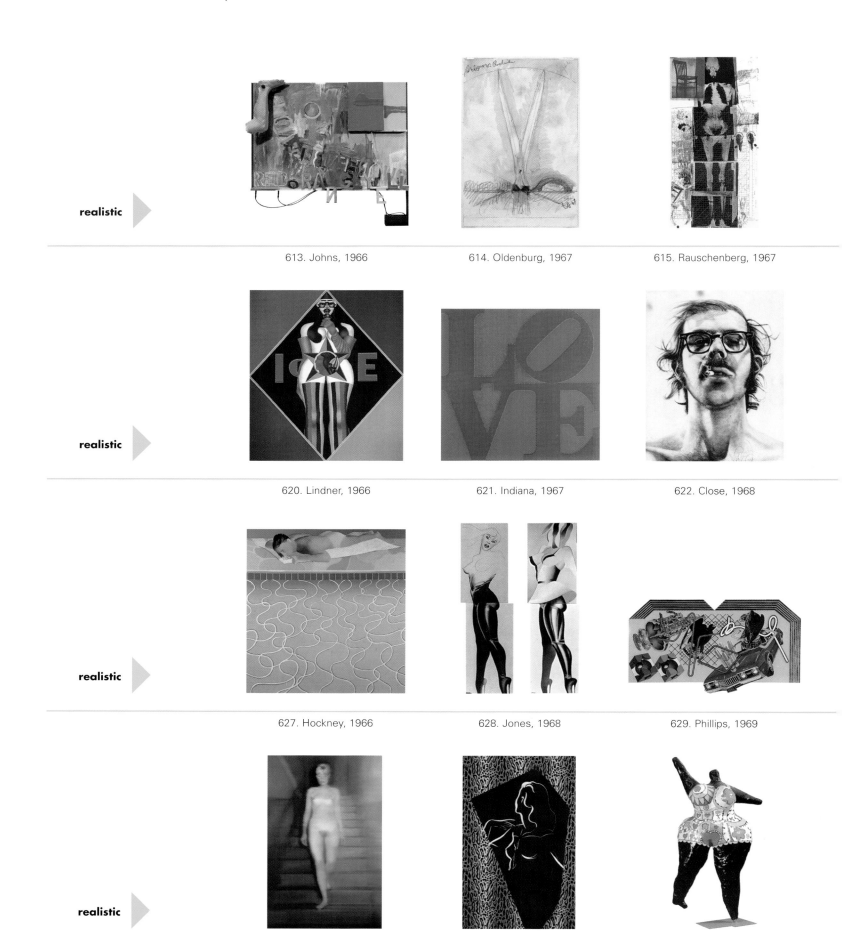

realistic ▷

613. Johns, 1966 614. Oldenburg, 1967 615. Rauschenberg, 1967

realistic ▷

620. Lindner, 1966 621. Indiana, 1967 622. Close, 1968

realistic ▷

627. Hockney, 1966 628. Jones, 1968 629. Phillips, 1969

realistic ▷

634. Richter, 1966 635. Polke, 1966 636. Saint Phalle, 1968/69

616. Oldenburg, 1969 617. Warhol, 1973 618. Rauschenberg, 1974 619. Oldenburg, 1976

623. Segal, 1969 624. Hanson, 1969 625. Lichtenstein, 1971 626. Guston, 1977

630. Hamilton, 1969 631. Tilson, 1970 632. Jones, 1972 633. Caulfield, 1979

637. Morley, 1968 638. Rot, 1969/70 640. Erró, 1975

111

1945–1980. Triumph and Consummation

664. Max Bill: *White From Complementary Colors*, 1959. Oil on canvas, 68 cm diagonal

692. Manfred Mohr: *P – 18 Random Walk*, 1969. Ink on paper, 60 x 50 cm

669. Victor Vasarely: *Tlinko*, 1956. Oil on canvas, 130 x 195 cm

The Structural Development
The ideology of the impersonal

The predominance of Abstract Expressionism is challenged in the late 1950s not only by the rise of Pop Art, but by new tendencies within structuralist, geometric nonrepresentative art. This development follows four different directions – Concrete Art, Kinetic Art, Hard Edge painting and Minimal Art, which we shall document here in four corresponding rows of pictures.[41]

■ *First row of pictures:* With the outbreak of the Second World War, neutral Switzerland became an important center of Constructivist art. Max Bill and Richard Paul Lohse – the two leading representatives of the group known as the Zürcher Konkreten – developed their own form of geometric abstraction based on straightforward mathematical principles (fig. **664**). In an essay published in 1948, Bill describes the process of composition as a kind of visual thinking: "*And the more exact the process of reasoning, the more homogeneous the basic idea, the more the thought will be in harmony with the methods of mathematical thinking, the closer we approach the primary structure and the more universal art becomes.*"[42]

In the 1960s, a few Constructivist artists begin to employ computer-aided design (fig. **692**), and already in 1970 a special exhibition of the Venice Biennale shows examples of Constructivist computer art alongside works by Bill and Albers.

■ *Second row of pictures:* Whereas in the United States and in the Protestant countries of Europe an ascetically stringent, purist art develops from the legacy of Bauhaus and De Stijl, in Paris a group of French and South American artists who draw on the same heritage instead evolve two variants of geometric nonfiguration that are far more playful and sensual than intellectual; these go down in history as Op Art and Kinetic Art. These artists are concerned less with structures than with examining retinal phenomena and the intrinsic value of movement.

Op Art is itself a form of kinetic art in the sense that its static visual works create the optical illusion of actual movement. Parallel lines, checkerboard patterns or concentric circles trigger flickering effects that the observer perceives as apparent motion. The confusing impact of such patterns (figs. 650, 668, **669**, 674, 696, 697) can be heightened by the use of complementary pairs of colors to create a simultaneous contrast, or by extremely subtle color differences that make it practically impossible to focus the eye.

The second kinetic current consists of works that actually do move, whether

[41] See Bocola, 1999, pp. 457–480.

[42] Max Bill, quoted in Rotzler, 1988, p. 120.

thanks to engines, the wind, water or human intervention. In our survey, works by the leading representatives of this literally Kinetic Art – Alexander Calder, Jean Tinguely and Nicolas Schöffer – are represented in the fourth row of pictures (figs. 657–660, 682–685).[43]

705. Ellsworth Kelly: *Yellow Orange*, 1968. Oil on canvas, two joined panels, 157.5 x 157.5 cm

■ *Third row of pictures:* The mystic and contemplative attitudes of Post Painterly Abstraction (see figs. 467–473 on pp. 94–95) find a structural articulation in American Hard Edge painting and its European counterparts.

The leading representative of this current is Ellsworth Kelly, whose painting picks up from Newman and the Russian Suprematists. In 1953 he quotes Malevich by painting a white square (fig. 654); not long after he derives from Rodchenko with three completely monochrome canvases: *Red, Yellow, Blue.* Later he arranges several different monochrome quadrilaterals into a multi-part shaped canvas (figs. **705**, 707). The work assumes the character of an object that exists independently of the artist. In the late 1970s, a current within Hard Edge known as Neo Geo initiates the transition to postmodernism (fig. 709).

714. Donald Judd: *Untitled*, 1969. Copper, mirrored, 10 units, each 23 x 102 x 79 cm, overall height 292 cm

■ *Fourth row of pictures:* Minimal Art differs from Hard Edge painting mainly through an expansion into the third dimension. In terms of the underlying mental attitude, the two currents are nearly identical.

Most of the Minimal artists work with simple, prescribed, industrially produced, often rectangular components, which are ordered according to clearly defined and easily legible principles to form single, self-contained configurations, or else larger systems and even entire environments.

Carl Andre uses prefabricated standard components – wooden beams, cement blocks, square steel plates – juxtaposing them in rows or rectangular areas on the floor, as in his *Floor Pieces,* or else fitting them together as free-standing sculptures (fig. 710). Donald Judd emphasizes the principle of alignment: identical rectangular bodies (open or closed cubes or blocks) are aligned at regular intervals, either side by side or attached to the wall one above the other (fig. **714**). Sol LeWitt applies similar principles to rows of open cuboid frames (fig. 711).
Dan Flavin works with standard neon tubes (figs. 688, 716). The combination of direct and indirect light or the juxtaposition of warm and cold sources of light achieve unusual and fascinating effects; the inherent impact of color, as the echo of an intangible cosmic whole, finds an immaterial and therefore all the more effective form.

[43] While Tinguely's and Schöffer's machines run on electricity, Calder's typically free-hanging constructions, for which Marcel Duchamp coined the term mobiles, are set into motion by the slightest touch or a breeze. These works are displayed in the fourth row.

1945–1980. Triumph and Consummation

The Structural Development

The predominance of Abstract Expressionism is challenged in the late 1950s not only by the rise of Pop Art, but by new tendencies within structuralist, geometric nonrepresentative art. These artists turn away from pathos and the supposed capriciousness of individual expression by espousing palpable and generally binding standards. Defining all of these works is the rigorous avoidance of any appearance of illusion or of any expression of feeling. The development pursues four different directions – Concrete Art, Op Art and Kinetic Art, Hard Edge painting, and Minimal Art – which we document here along four timelines.

The first row starts with Max Bill's and Richard Paul Lohse's initiation of Concrete Art, a geometric nonfiguration that gives visual form to mathematic principles of order.

The second row follows the development of the kinetic form known as Op Art and its use of confusing optical effects to create the illusion of patterns in motion.

The third row shows how Hard Edge painting picks up from Barnett Newman and moves through the early works of Kelly and Albers to the shaped canvases of Kelly, Mangold and the already rather postmodern works of McLaughlin and Federle.

The fourth row begins with the Kinetic Art works of Calder, Tinguely and Schöffer, leading to the pathbreaking English metal sculptor Anthony Caro and the most important exponents of American Minimal Art.

structural

641. Bill, 1946

structural

646. Vasarely, 1949

structural

651. Newman, 1950

structural

656. Moholy-Nagy, 1950

642. Lohse, 1949/50

643. Graeser. 1952

644. Vordemberge-Gildewart, 1953

645. Wyss, 1954

647. Soto, 1951

648. Morellet, 1952

650. Morellet, 1954

652. Kelly, 1951

653. Kelly 1952/53

654. Kelly, 1953

655. Albers, 1954

657. Calder, 1950

659. Tinguley, 1954

660. Tinguely, 1955

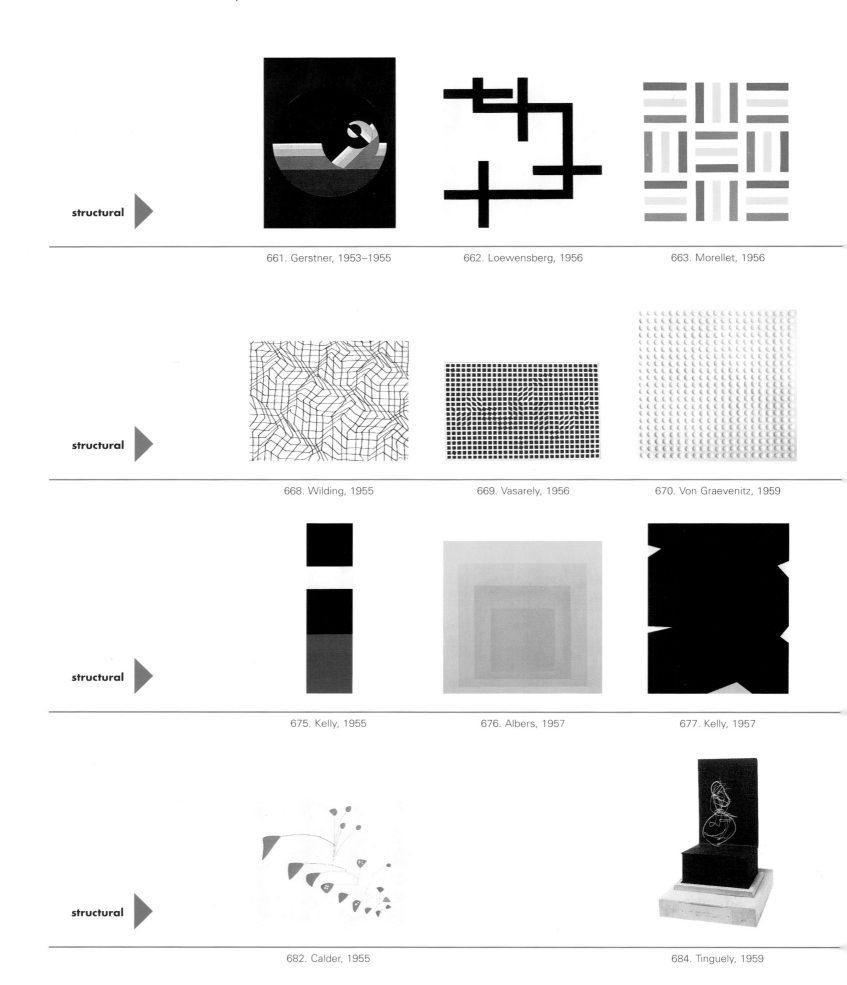

structural ▶

661. Gerstner, 1953–1955 662. Loewensberg, 1956 663. Morellet, 1956

structural ▶

668. Wilding, 1955 669. Vasarely, 1956 670. Von Graevenitz, 1959

structural ▶

675. Kelly, 1955 676. Albers, 1957 677. Kelly, 1957

structural ▶

682. Calder, 1955 684. Tinguely, 1959

116

664. Bill, 1959 665. Graeser, 1959/60 666. Lohse, 1962 667. Lohse, 1963

671. Vasarely, 1959 672. Mack, 1960 674. Anuszkiewicz, 1965

678. Kelly, 1960 679. Nemours, 1960 680. Smith, 1962 681. Kelly, 1965

685. Schöffer, 1960 686. Caro, 1962 687. Smith, 1962 688. Flavin, 1964

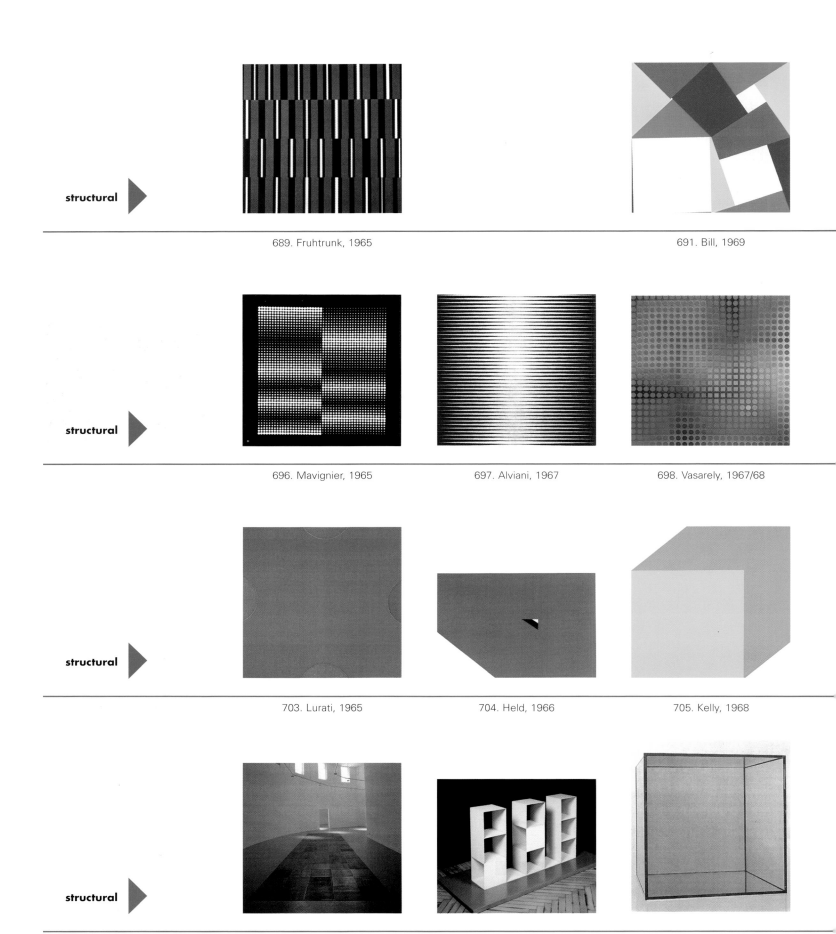

structural ▶

689. Fruhtrunk, 1965

691. Bill, 1969

structural ▶

696. Mavignier, 1965

697. Alviani, 1967

698. Vasarely, 1967/68

structural ▶

703. Lurati, 1965

704. Held, 1966

705. Kelly, 1968

structural ▶

710. Andre, 1967

711. LeWitt, 1967

712. Bell, 1969

692. Mohr, 1969 693. Buren, 1972 694. Lohse, 1972 695. Mohr, 1977–1980

699. Le Parc, 1969 700. Agam, 1969/70 702. Held, 1978

706. Mangold, 1968 707. Kelly, 1971 708. McLaughlin, 1974 709. Federle, 1977

713. Morris, 1969 714. Judd, 1969 715. Judd, 1974 716. Flavin, 1975

1945–1980. Triumph and Consummation

740. Edward Kienholz: *John Doe,* 1959. Free-standing assemblage of various materials, 100 x 50 x 80 cm

741. Alberto Giacometti: *Standing Woman I,* 1960. Painted bronze, height 270 cm

750. Antoni Tàpies: *Black with Two Lozenges,* 1963. Oil on canvas, 411.5 x 330.2 cm

44 See Bocola, 1999, pp. 481–537.

The Symbolist Development
Magic and ritual

We conclude our survey of artistic evolution in the postwar period with modernist symbolism, which arises in figurative, nonfigurative, object-like and emblematic forms.[44]

■ *First row of pictures:* The first timeline documents the development from the fantastic Surrealism of the early 1940s to a figurative, representational Surrealism that relates to reality and uses the human being as a central figure.

Most of the works reproduced here testify to profound doubts about Modernism and its faith in the future. In Jean Dubuffet, Edward Kienholz, Francis Bacon and Pablo Picasso, human figures are deformed, dismembered and distorted, confronted with terror and death (figs. 717, 721, **740**, 742, 768, 770).

The existential crisis of this art finds a more silent but all the more moving articulation in the works of Alberto Giacometti. His expressive, elongated, dematerialized figures lend radiant and unmistakable artistic signification to the threat and spiritual isolation of modern people (figs. 718, 719, 738, **741**, 765).

■ *Second row of pictures:* Jean Fautrier and Wols (figs. 722, 723) are the bridge from the European Informel movement to an object-like, materially oriented and largely nonfigurative painting, and to a visual understanding that aims at resolving the antinomy between the pictorial medium and its content, without reducing the work's statement entirely to color and form.

The key artists of this tendency are the Spaniard Antoni Tàpies, the Italians Lucio Fontana and Piero Manzoni and the French artist Yves Klein.

Tàpies covers the surface of his pictures with a mortar-like mixture of plaster, paste and sand, lending them the appearance of old, crumbling masonry. He scrapes linear signs into the irregular surface, drills holes, scrapes layers away and occasionally sets a color highlight (figs. 744, **750**). The traces of his interventions do not result in a picture in the conventional sense, but bear sober and silent witness to an unknown, mysterious occurrence.

With their almost monochrome appearance and their solemn stillness, these works have a certain affinity with the paintings of Mark Rothko, but unlike these they do not call for mystical union; they are the bearers of a message. Even if it cannot be deciphered, it confronts the viewer with an unknown meaning. Antoni Tàpies's wall-like panels gain an enigmatic, magical significance and are the first

example in postwar art of a tendency we should like to describe as nonfigurative symbolism.

Fontana lends the dimension of nothingness a certain "positive," dramatic form by slitting or perforating the monochromatic surface of his canvasses, ceramics and metal plates (figs. 724, 747, 772, **773**, 775). Through constant repetition the sadistic intervention of causing injury to the unadulterated surface, without "soiling" it with paint, is finally transformed into magic ritual.

Manzoni also works with a reduced vocabulary, for example by placing white material such as wadding, cotton, felt or fiberglass in simple arrangements under glass (fig. 746). The visual aspect becomes increasingly less important in his late works. In 1960 he presents his *Merde d'artiste (Artist's Shit)* in hermetically conserved metal containers (fig. 749), a work that is no longer visible, but must be imagined.

The tendency towards the mystification of the immaterial, of things that are merely thought or imagined, takes its most radical form in the work of Yves Klein. He carves out his particular niche in art history in a legendary 1957 exhibition at the Gallerie Apollinaire in Milan, where he presents 12 rectangular monochrome paintings of pure ultramarine blue, entirely identical in format, color and painterly execution. His use of monochrome and preference for ultramarine blue become the hallmark of his work; he calls himself *Yves le monochrome.* At first producing only panel paintings, he later appropriates all manner of objects by painting them in ultramarine (like the sponges in fig. 745), attaching them to a base or mounting them on a plinth and declaring them to be sculptures.

At the end of this particular timeline we find the followers of Land Art (figs. **776**–778), who hit upon the new artistic medium of shaping natural or industrial landscapes. Traveling to remote, uninhabited regions around the world, they dig trenches, draw lines of limestone across the earth for hundreds of yards, order stones and boulders in circles or pile them up in heaps. These transient documents of human presence in empty places otherwise untouched by humankind turn the landscape itself into a work of art.[45]

Land Art is inspired generally by the art and mythology of other, often long defunct civilizations. Among its most important inspirations are the magical stone structures of Stonehenge (ca. 19th to 15th centuries BCE) and the huge earth drawings with which the former inhabitants of the Peruvian pampa hoped to communicate with higher beings and supernatural powers (ca. 300 BCE to 700 CE).

Parallel to the magic, almost sacral works of Land Art, we follow a more secular and contemporary variant of it that prefers industrial techniques and materials.

773. Lucio Fontana: *Concetto spaziale, Attese 66 T 40,* 1966. Watercolor on canvas, 146 x 114 cm

776. Robert Smithson: *Spiral Jetty,* 1969/70. Rock, salt crystals and water, coil, length 457 m, width approximately 4.5 m

[45] *Bildlexikon der Kunst,* 1976, pp. 357–358. The leading proponents of Land Art are Richard Long, Michael Heizer, Walter de Maria, Dennis Oppenheim and Robert Smithson.

731. Robert Rauschenberg: *Untitled (Elemental Sculpture)*, 1953. Assemblage: wood block, square-headed nails, rope and tethered stone, block 16.2 x 43.2 x 8.9 cm, stone 7.6 x 22.9 x 13 cm, rope (extended) 74.9 cm

756. Joseph Beuys: *Crucifixion*, 1962/63. Wood, nails, electric wiring, string, needles, cord, 2 plastic bottles, newspaper, oil paint (brown cross), plaster, 42.5 x 19 x 15 cm

785. Jannis Kounellis: *Untitled; Woman's Head With Gas Flame*, 1975. Fragment of a plaster cast head with a propane gas torch on a steel pedestal, fragment 28 x 28 x 12 cm, pedestal 125 x 40 x 40 cm

The "wrapped object" artists Christo and Jeanne-Claude transform the arrangement of landscapes, as in our example by erecting a fabric fence of several kilometers length (fig. 777). The weirdest and most modern of all works of this kind is surely the American artist Walter de Maria's *Lightning Field* – a group of 400 stainless steel poles, averaging 6.3 meters in height, arranged in a rectangular lattice (fig. 778). These act as lightning rods, and during thunderstorms the field generates spectacular meteorological performances.

Works such as these are highly dependent on photography and video to publicize and preserve their results.

■ *Third row of pictures:* This row follows the development of Arte Povera. The true pioneer of this current is the American Robert Rauschenberg, who in a series of object assemblages in the early 1950s first demonstrated the expressive potential of cheap, artistically untouched objects and materials (figs. 729–**731**, 736).

Jannis Kounellis, Mario Merz, Giovanni Anselmo and a number of other artists in Italy during the 1960s and 1970s began to operate with unprepossessing objects in a way similar to Rauschenberg's. To describe them, the Italian art critic Germano Celant coined the term Arte Povera, which today refers to all exponents of this tendency, in Germany including Joseph Beuys and in the United States, Eva Hesse and the early Richard Serra.

The works of Arte Povera evoke the fetishes and cult worship of primitive, animistic tribal cultures. Beuys himself takes the role of a shaman who uses manipulation and suggestive theater to transform ordinary objects like plastic bottles, tools, felt mats, honey, fat and all manner of industrial garbage into instruments of magical power (figs. 755, **756**, 780).

In her strange structures and installations, Eva Hesse has a preference for easily shaped material like rubber, polyester, glass wool, polyesters and synthetic resins (figs. 757, 779, 783).
Merz works with soil, clay and foliage, sacks of sand or giant bundles, emphasizing the archaic character of the materials by contraposing them to the blue artificial light of mysterious letters in neon (figs. 781, 782).
Kounellis often combines butane gas flames with rusting metal plates, banal objects or relics of Graeco-Roman antiquity (fig. **785**).

In all of these cases, the work becomes the carrier of a mysterious and incomprehensible message that acquires its magical significance through its indecipher-

ability. Arte Povera and the currents related to it (see the fourth row) are aptly described as examples of magical symbolism.

■ *Fourth row of pictures:* Proceeding from the mysterious boxes made by the American Surrealist artist Joseph Cornell (figs. 732–734) and the early works of Jasper Johns (figs. 758, 759) and Robert Rauschenberg, the three artists Bruce Nauman, Richard Serra (fig. **789**) and Keith Sonnier (fig. 790) create an American variant of object-like, magical symbolism.

Nauman's work revolves around physical experiences; most of his early works are specifically tailored to the sizes or forms of his own body (figs. 763, **786**, 787). Like Merz, Serra and Sonnier, he has a predilection for the evocative potentials of neon light as an embodiment of modern magic. His later works are mainly in video and installations (fig. 981 on p. 153).

With their works, all of these artists meet the requirements outlined by Jean Moréas in his Symbolist Manifesto of 1886, of *"never going as far as to fix a definition or directly state the idea"* and his assertion that *"scenes of nature, the actions of human beings, all concrete phenomena cannot manifest themselves as such: they are sensible appearances destined to represent their esoteric affinities with primordial Ideas."*[46] Their approach also stems from a central tenet of Modernism: the artist should not portray reality, but create a new reality.

786. Bruce Nauman: *Neon Templates of the Left Half of My Body Taken at Ten-Inch Intervals*, 1966. Neon tubing on clear glass tubing suspension frame, 177.8 x 22.9 x 15.2 cm

789. Richard Serra: *Floor Pole Prop*, 1969. Antimony and lead, 250 x 250 x 95 cm

[46] Jean Moréas, "Symbolism – a Manifesto," originally published in the *Supplement littéraire du Figaro* on Sept. 18, 1886; excerpted in *Art in Theory 1815–1900*, p. 1015 (translation by Akane Kawakami).

1945–1980. Triumph and Consummation
The Symbolist Development

Modernist symbolism, with which we conclude our survey of artistic evolution in the postwar period, arises in figurative, nonfigurative, object-like and emblematic forms.

The first row shows the development of a figurative symbolism that raises as its central concern the question of the meaning and integrity of human existence.

The second row shows the leading exponents of a non-figurative, materially oriented symbolist art that operates with minimal means; artists like Klein and Fontana exploit the suggestive potentials of activating empty planes. The series concludes with examples of Land Art.

The third row follows the development of Arte Povera from the early, modest works by Rauschenberg and Twombly to the fetishistic objects and assemblages by Beuys, Hesse and Merz, as well as the surprising articulations by the Greek artist Kounellis.

The fourth row shows related developments in the United States, from the legendary boxes by the Surrealist Joseph Cornell and the early works of Jasper Johns to an American variant of an object-like magical symbolism.

symbolist ▶

717. Dubuffet, 1947

symbolist ▶

722. Fautrier, 1945

symbolist ▶

symbolist ▶

732. Cornell, 1946

718. Giacometti, 1947 719. Giacometti, 1950 720. Dubuffet, 1950 721. Bacon, 1953

723. Wols, 1947 724. Fontana, 1949 725. Burri, 1953 726. Rauschenberg, 1953

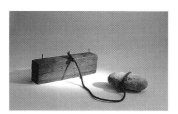

729. Rauschenberg, 1952 730. Rauschenberg, 1953 731. Rauschenberg, 1953

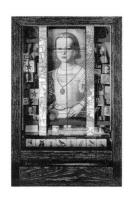

733. Cornell, 1948 734. Cornell, 1950–1952 736. Rauschenberg, 1953

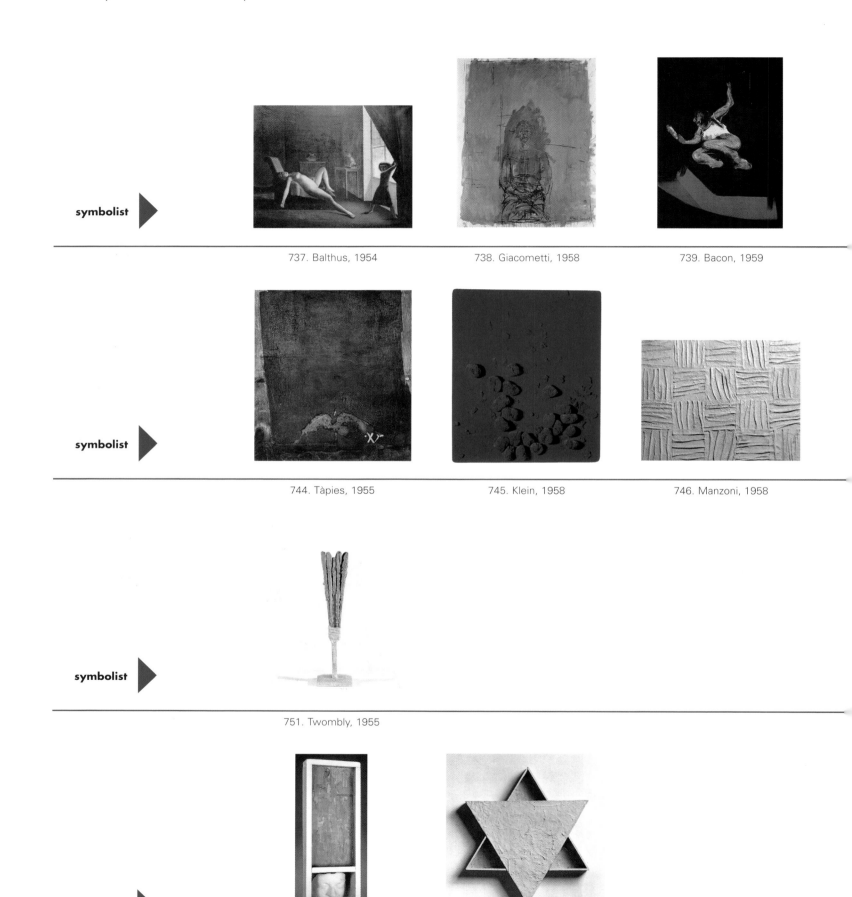

symbolist ▶

737. Balthus, 1954 738. Giacometti, 1958 739. Bacon, 1959

symbolist ▶

744. Tàpies, 1955 745. Klein, 1958 746. Manzoni, 1958

symbolist ▶

751. Twombly, 1955

symbolist ▶

758. Johns, 1954 759. Johns, 1954

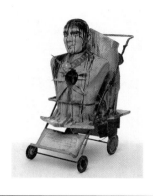

740. Kienholz, 1959

741. Giacometti, 1960

742. Kienholz, 1962

743. Johns, 1964

747. Fontana, 1959

748. Klein, 1961

749. Manzoni, 1961

750. Tàpies, 1963

754. Kounellis, 1959

755. Beuys, 1960

756. Beuys, 1962/63

757. Hesse, 1965

763. Nauman, 1964/65

764. Serra, 1966/67

1945–1980. Triumph and Consummation

The Symbolist Development

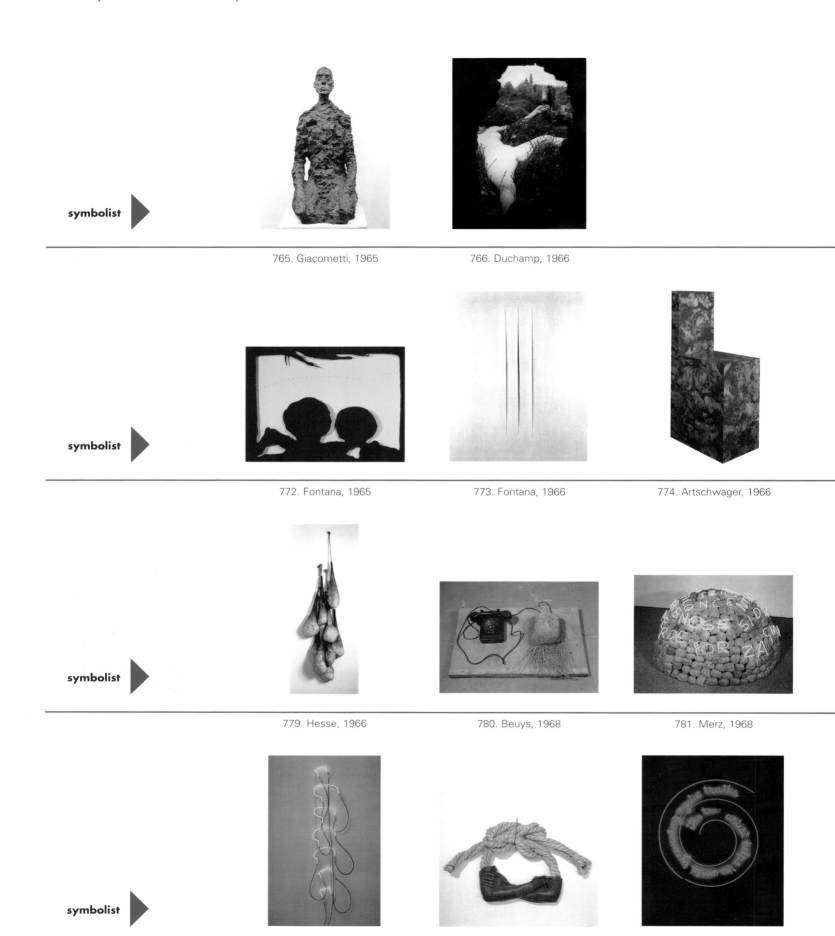

symbolist ▶

765. Giacometti, 1965 766. Duchamp, 1966

symbolist ▶

772. Fontana, 1965 773. Fontana, 1966 774. Artschwager, 1966

symbolist ▶

779. Hesse, 1966 780. Beuys, 1968 781. Merz, 1968

symbolist ▶

786. Nauman, 1966 787. Nauman, 1967 788. Nauman, 1967

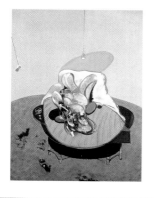
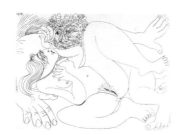
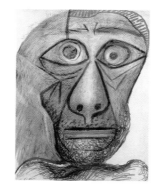
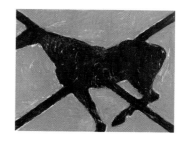

768. Bacon, 1969 769. Picasso, 1969 770. Picasso, 1972 771. Rothenberg, 1976

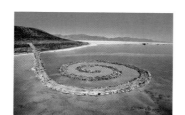

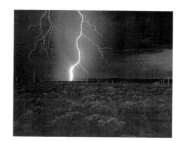

775. Fontana, 1968 776. Smithson, 1969/70 777. Christo & Jeanne-Claude, 1976 778. De Maria, 1977

782. Merz, 1968 783. Hesse, 1969 784. Rauschenberg, 1973 785. Kounellis, 1975

789. Serra, 1969 790. Sonnier, 1969 791. Nauman, 1973 792. Paik, 1975

Yaacov Agam 1928
Josef Albers 1888–1976
Getulio Alviani 1939
Carl Andre 1935
Richard Anuszkiewicz 1930
Karel Appel 1921
Arman (Armand Fernandez) 1928
Richard Artschwager 1924
Francis Bacon 1909–1992
Balthus (Balthazar Klossowski
de Rola) 1908
Jean Bazaine 1904
Lary Bell 1939
Joseph Beuys 1921–1986
Max Bill 1908–1994
Peter Blake 1932
Derek Boshier 1937
James Brooks 1906–1992
Daniel Buren 1938
Alberto Burri 1915–1995
Alexander Calder 1898–1976
Anthony Caro 1924
Patrick Caulfield 1936
César (César Baldaccini) 1921–1998
Christo (Christo Javacheff) & Jeanne-Claude
(Jeanne-Claude de Guillebon) 1935
Chuck Close 1940
Joseph Cornell 1903–1972
Stuart Davis 1894–1964
Richard Diebenkorn 1922–1993
Jim Dine 1935
Martin Disler 1949–1996
Jean Dubuffet 1901–1985
Marcel Duchamp 1887–1968
Erró (Gudmundur Gudmundsson) 1932
Jean Fautrier 1898–1964
Helmut Federle 1944
Dan Flavin 1933–1996
Lucio Fontana 1899–1968
Sam Francis 1923–1994
Helen Frankenthaler 1928
Günter Fruhtrunk 1923–1982
Karl Gerstner 1930
Alberto Giacometti 1901–1966
Arshile Gorky 1905–1948
Adolph Gottlieb 1903–1974
Camille Graeser 1892–1980
Gerhard von Graevenitz 1934–1983
Philip Guston 1913–1980
Raymond Hains 1926
Richard Hamilton 1922
Duane Hanson 1925–1996
Hans Hartung 1904–1989
Pierre Haubensak 1935
Al Held 1928
Eva Hesse 1936–1970

David Hockney 1937
Hans Hofmann 1880–1966
Robert Indiana 1928
Jasper Johns 1930
Ray Johnson 1927
Allen Jones 1937
Asger Jorn 1914–1973
Donald Judd 1928–1994
Allan Kaprow 1927
Ellsworth Kelly 1923
Edward Kienholz 1927–1994
Ronald B. Kitaj 1932
Konrad Klapheck 1935
Yves Klein 1928–1962
Franz Kline 1910–1962
Willem de Kooning 1904–1997
Jannis Kounellis 1936
Julio Le Parc 1928
Sol LeWitt 1928
Roy Lichtenstein 1923–1997
Richard Lindner 1901–1978
Verena Loewensberg 1912–1986
Richard Paul Lohse 1902–1988
Morris Louis 1912–1962
Luigi Lurati 1936–1967
Heinz Mack 1931
Alfred Manessier 1911–1993
Robert Mangold 1937
Piero Manzoni 1933–1963
Brice Marden 1938
Walter de Maria 1935
Georges Mathieu 1921
Henri Matisse 1869–1954
Almir Mavignier 1925
John McLaughlin 1898–1976
Mario Merz 1925
Joan Miró 1893–1983
László Moholy-Nagy 1895–1946
Manfred Mohr 1938
François Morellet 1926
Malcolm Morley 1931
Robert Morris 1931
Robert Motherwell 1915–1991
Bruce Nauman 1941
Ernst Wilhelm Nay 1902–1968
Aurelie Nemours 1910
Barnett Newman 1905–1970
Kenneth Noland 1924
Claes Oldenburg 1929
Jules Olitski 1922
Nam June Paik 1932
Eduardo Paolozzi 1924
Peter Phillips 1939
Pablo Picasso 1881–1973
Sigmar Polke 1942
Jackson Pollock 1912–1956

Mel Ramos 1935
Robert Rauschenberg 1925
Ad Reinhardt 1913–1967
Gerhard Richter 1932
Jean-Paul Riopelle 1923
James Rosenquist 1933
Diter Rot 1930–1998
Mimmo Rotella, 1918
Susan Rothenberg 1945
Mark Rothko 1903–1970
Robert Ryman 1930
Niki de Saint Phalle 1930
Antonio Saura 1930
Marcel Schaffner 1931
Nicolas Schöffer 1912–1992
Emil Schumacher 1912–1999
Kurt Schwitters 1887–1948
George Segal 1924
Richard Serra 1939
Kimber Smith 1922–1981
Tony Smith 1912–1980
Robert Smithson 1938–1973
K.R.H. Sonderborg 1923
Keith Sonnier 1941
Jesús Rafael Soto 1923
Pierre Soulages 1919
Daniel Spoerri 1930
Nicolas de Staël 1914–1955
Frank Stella 1936
Clyfford Still 1904–1980
Antoni Tàpies 1923
Joe Tilson 1928
Jean Tinguely 1925–1991
Mark Tobey 1890–1976
Bradley Walker Tomlin 1899–1953
Cy Twombly 1929
Victor Vasarely 1908–1997
Emilio Vedova 1919
Jacques Mahé de la Villeglé 1926
Friedrich Vordemberge-Gildewart
1899–1962
Andy Warhol 1928–1987
Tom Wesselmann 1931
Ludwig Wilding 1927
Wols (Alfred Otto Wolfgang
Schulze) 1913–1951
Marcel Wyss 1930

1980–2000
The End of Modernism

1980–2000. The End of Modernism

The developments of the years from 1945 to 1980, as described in the previous chapter, took place in an era when the ideas of Modernism had become prevalent in Western societies.

In the space of two decades after the Second World War, common cultural roots, similar political views, rapid developments in communications and the mass media, close economic cooperation and the common threat of the Communist bloc brought the Western democracies together into a uniform cultural region with a liberal intellectual climate and constantly rising prosperity, which in turn drove forward scientific, technological, artistic and social developments at an ever faster tempo. The cultural euphoria of the West, the feeling that everything is possible and doable, reached its high point in the late 1960s with the first manned moon landing by the Americans on July 20, 1969.

By the early 1970s and beyond, contemporary and modern art enjoyed a peerless popularity. New museums and art galleries were established everywhere in Europe, Japan and the United States, putting on exhibitions that attracted increasingly large crowds. The art trade flourished. Year after year, dozens of international art fairs were held, with revenues constantly growing. The big auction houses recorded new price records with each season. Works by living artists such as Jasper Johns, Robert Rauschenberg, Cy Twombly and Frank Stella were sold for millions, while the paintings of young stars, unknown a few years before, made five-figure dollar prices.

This transformed not only the material situation, but also the self-concept of contemporary artists. They no longer felt like outsiders to society, but were thoroughly integrated. The model of the starving genius remaining true to his ideals despite the lack of success is definitively passé. To exaggerate only slightly, almost every young artist views him or herself as a potential millionaire.[47]

Until now, innovation has been the key to artistic success. But in contrast to the established stars, the new generation of artists in the 1980s look back on an artistic cycle that has been largely completed.

During the course of its development, the essential underlying idea of Modernism – the notion of an invisible reality and the basic unity of all being, the comprehensive and universal order of physical, biological, psychological and intellectual powers – has been elucidated, varied, consolidated, and confronted with reality both in its rational (realistic and structural) and also irrational (romantic and symbolist) points of view. The ambition of lending artistic expression to this basic idea in a unique and comprehensive way has generated ever clearer, intenser and purer articulations and concepts, which can no longer be surpassed in terms of their innovation, persuasion or pointedness. The outer limits and final logical conclusions

1017. Edwin "Buzz" Aldrin walking on the moon, as filmed by Neil Armstrong, July 20, 1969

1018. Van Gogh's *Sunflowers* are auctioned for a record sum of 55 million dollars, March 30, 1987

[47] See Bocola, 1999, pp. 549–592.

1019. Mario Merz: *Che fare? (What is to be done?)*, 1968. Pan, wax and neon lettering, 15 x 45 x 18 cm

849. Andy Warhol: *Philip's Skull*, 1985. Silk screen on acrylic on canvas, four panels, each 101.5 x 101.5 cm

889. Max Bill: *7 Colors for 7 Pythagorean Triangles in a Square*, 1980–1982. Oil and acrylic on canvas, 150 x 150 cm

[48] Hughes, 1980, p. 376.

of the development initiated a hundred years ago by Seurat, Cézanne, Van Gogh and Gauguin have been reached.

This was the situation which led to two developmental tendencies in the 1980s. First, the veterans of the postwar artistic revolution – Abstract Expressionism, Pop Art, Op Art, Concrete Art, Hard Edge, Minimal Art, nonfigurative Symbolism, Arte Povera – continued to modify or refine their creative achievements, generally without breaching new horizons (figs. **849**, 951, 973). Second, younger artists, whose prime concern is to show their own uniqueness and create something new, find themselves faced with the question that Mario Merz has written on the wall or added in neon writing to a number of his installations: *Che fare? (What is to be done?* – fig. **1019**). They respond with refusal or exaggeration; they refuse to pander to the demands for innovation, style and integrity that hitherto shaped the artistic developments of Modernism – which can no longer be fulfilled – while at the same time they work themselves up to a grandiose self-image of unconditional artistic freedom. In other words, they are no longer willing to meet the demands of a supraliminal and idealized value structure. Conceptually and creatively, their art knocks over all remaining taboos and surrenders most of the traditional goals.

In his famous book, *The Shock of the New – Art and the Century of Change*, Robert Hughes interprets this phenomenon as follows:

"When one speaks of the 'end of Modernism' (and the idea of a 'post-modernist' culture, however ill-defined, has been a comonplace since the mid-seventies), one does not invoke a sudden historical terminus. Histories do not break off clean, like a glass rod; they fray, stretch and come undone, like rope; and some strands never part. There was no specific year in which the Renaissance ended, but it did end, although culture is still permeated with the remnants of Renaissance thought. So it is with modernism, only more so, because we are that much closer to it. Its reflexes still work, its limbs move, the parts are mostly there, but they no longer seem to function as a live organic whole. The modernist achievement will continue to affect culture for decades to come, because it was so large, so imposing, and so irrefutably convincing. But our relation to its hopes has become nostalgic. The age of the New, like that of Pericles, has entered history." [48]

The idea that Modernism has ended is not restricted to art mediators and philosophers, it is also shared by politicians, sociologists and economists. Vaclav Havel, president of the Czech Republic, expressed a widely held opinion when he declared on July 4, 1994: *"I think there are good reasons for suggesting that the modern age has ended. Today, many things indicate that we are going through a transitional period, when it seems that something is on the way out and something else is painfully being born. It is as if something were crumbling, decaying, and*

exhausting itself, while something else, still indistinct, were arising from the rubble." [49]

The artistic development of the last 20 years reflects this epochal change, the beginnings of which can be traced back to the 1970s, when a report by an international group of scientists, tellingly entitled "The Limits of Growth," questioned vital aspects of the development that had brought unprecedented prosperity to the Western industrial countries. Citing exhaustive factual evidence, the authors warned against the devastating effects of uncontrolled economic growth – increasing environmental pollution, the worldwide production and dispersal of toxins, and a reckless exploitation of non-regenerative raw materials. Their report roused worldwide attention, but did not move the Western democracies to change their environmental policies.

The growing corruption in political and economic circles, the rampant spread of organized crime, rising crime rates and drug use, the ongoing globalization of the economy and the inability of governments and political parties to master the related social problems led in the final decades of the 20th century to a general disillusionment. Broad strata of the population lost confidence in the moral integrity of their leading elites and role-models, and lost faith in the sense and validity of their ideals and values. The guiding societal ideals of the early Modern Era have apparently ceded their power to persuade and inspire their adherents with ideas for the future.

Certainly the most far-reaching societal development of the outgoing early Modern Era lies in the spectacular progress of modern means of genetic biotechnology, electronic communications and the mass media. The global social effects of this technological revolution, which signals the dawn of a new era, cannot be covered in depth here. For our purposes, we shall note that the aesthetic awareness of the outgoing 20th century was defined largely by the ever greater flood of information disseminated daily to the population via press, radio and television.

Greatest was the impact of television. Its powerful subversive effect lies partly in the way it conveys a completely new experience of reality, far removed from previous conditions of time and space, within which distinctions between fiction and reality are constantly shifted and blurred. The permanent simultaneity of news reporting, entertainment and advertising and the constant change in settings and levels of reality – from the crime thriller to the news, followed by sports or an art exhibition – undermine every possible emotional response, rob events of their context, and contribute to the progressive fragmentation and aestheticization of the collective realm of experience. This development was intensified in the late 1990s by the rise and worldwide implementation of the Internet.

[49] Vaclav Havel, "The Need for Transcendence in the Post-Modern World"; a speech held by the President of the Czech Republic at Independence Hall, Philadelphia on July 4, 1994, reprinted in the *International Herald Tribune* on July 11, 1994.

945. Francesco Clemente: *Smoke in the Room*, 1983. Pastel on paper, 60.5 x 45.5 cm

853. Keith Haring: *Untitled*, 1984. Acrylic on untreated cotton cloth, 152 x 152 cm

856. Lucian Freud: *Naked Portrait with Reflection*, 1980. Oil on canvas, 228.6 x 228.6 cm

This ideational and aesthetic fragmentation is found also in the "innovative" artistic production of the 1980s and 1990s, with its eclecticism and disregard for supra-individual intellectual values in some ways recalling the Salon art of the late 19th century.[50] I shall use postmodern art as the general term for these artists and artistic movements – the Transavanguardia in Italy (figs. 942, 944, **945**), the Neue Wilden in Germany (figs. 809–812, 834), Neo-Expressionism and New Figuration (figs. **856**–858), Pattern & Decoration (figs. 806–807 and 827–831), Graffiti Art (figs. 851–**853**), Neo Geo (figs. 802, 820, 821, 898–902, 911, 915).

While I cannot go into the many interpretations of the catchword postmodernism here, it indicates the essential aspect of an art that can no longer be categorized as modernist, since it ignores and rejects Modernism's guiding maxims; but which also does not represent a new beginning, because it does not set up new artistic values or give expression to a new paradigm. It is thus definable only as following what has come before, as an intermezzo between the already completed final phase of Modernism and the still unformed first phase of a new historic age, in which a new creative consciousness and a new artistic idiom presumably will arise, step by step.

Today we lack the necessary distance to decipher accurately the artistic production of postmodernism, or to locate it within the categories of art history – i.e., to recognize how far and in what way it already carries within it the germ of a new beginning. We can only note a few of its most conspicuous qualities.

Instead of developing an independent artistic language, the exponents of these currents adopt the stylistic forms, themes and material of their art, meaning their entire set of creative tools, from Modernism. The ideational and stylistic fragments of earlier artistic forms are not used and quoted in their original purity, but often combined with other, often contradictory forms, so that they lose their previous character as statements. Although it derives from already formulated sources, postmodernist art generally combines these with a complete lack of respect for those sources; the primary undertone of postmodernism consists in a mixture of irony, cynicism and satire (figs. 865, 901, 922). This art has given up any claim to universal validity. In the struggle for ever-scarcer public attention, the thrust is towards direct, momentary and intense stiumlations. This attitude finds its most extreme articulation in the works of Jeff Koons (fig. **845**) and the young British artists sailing under the banner of Britart, who roused worldwide attention with the 1997 exhibition, Sensation (fig. 970, p. 153). Art becomes a spectacle and a category of consumer good, a part of the entertainment industry integrated in the economy.

Although the electronic media are increasingly significant in this process, we cannot give appropriate documentation to these works here, because they occur as

[50] In this volume, see "The End of the Early Modern Era," p. 20, last section.

events in time. The same is true of art environments and performance, which are represented only in a few examples (figs. 954, 956, **979**, 981, 984).

Once again, we shall organize the artistic development of the last 20 years in four basic attitudes, each of which is documented in four rows of pictures. Of course, the eclectic pluralism of this development and the ideational opportunism of its artists mean that many of the works depicted are difficult to place within one of the four basic artistic tendencies. Thus, we retain in the final section of our survey the order employed until now, but without presenting introductory texts to each of the basic attitudes.

845. Jeff Koons: *Pink Panther,* 1988. Porcelain, 104.1 x 52.1 x 48.3 cm

979. Jenny Holzer: *Protect Me from What I Want,* 1987. Installation, San Francisco

1980–2000. The End of Modernism
The Romantic Development

The first two rows display works that in a broad sense follow the two main currents of Abstract Expressionism – Action Painting and Color Field Painting. These works remain largely true to the original attitudes underlying the movements of old, and thus set forth the artistic development of Modernism (see figs. 813, 817, 819, 798, 800, 820, 821, 822).

Most of the works in the third row refuse the demands of the canon to date. Their creators withdraw from the idiom of Abstract Expressionism and take up an agreeable, pseudoromantic nonfigurative painting of a harmlessly decorative cast (figs. 803, 805, 806, 807, 828, 829, 830, 831, 833).

Absent from these works is the distinctive composure that imbued the expressions of early Abstract Expressionism with a certain grandeur and lasting dignity.

The fourth row begins with the British Expressionist artist Auerbach (fig. 808) and goes on into the Neue Wilde (figs. 809–812, 834). This painterly, figurative expressionism is taken up by Disler and Hasenböhler (figs. 836, 838) and many other European artists, and stands out as the most spectacular postmodernist contribution to romantic art in the 1980s.

romantic ▶

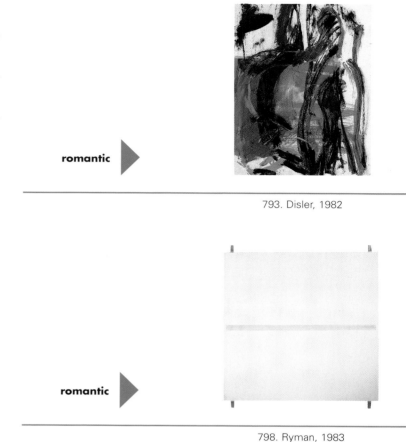

793. Disler, 1982

romantic ▶

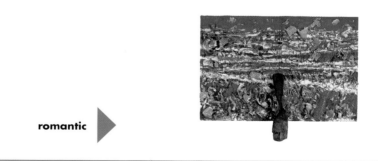

798. Ryman, 1983

romantic ▶

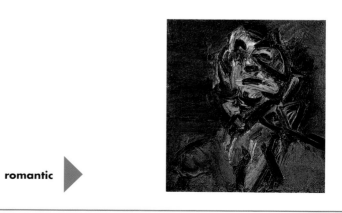

803. Schnabel, 1981

romantic ▶

808. Auerbach, 1981

794. Kirkeby, 1984 795. Richter, 1983 796. Hodgkin, 1984 797. Kirkeby, 1988

799. Scully, 1984 800. Spescha, 1985 802. Federle, 1987

805. Buthe, 1984 806. Zeniuk, 1986 807. Oehlen, 1988

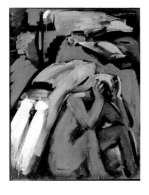

809. Baselitz, 1981 810. Middendorf, 1981 811. Fetting, 1983 812. Hödicke, 1983

romantic ▶

813. Schaffner, 1989 814. Moses, 1989 815. Lasker, 1991

romantic ▶

820. Haubensak, 1989 821. Förg, 1990 822. Noland, 1991

romantic ▶

827. Natkin, 1990 828. Glasco, 1990 829. Taaffe, 1990

romantic ▶

834. Baselitz, 1989 835. Winters, 1988 836. Disler, 1989–1991

816. Girke, 1992 817. Marden, 1991–1993 818. Marden, 1991–1995 819. Wilen, 1998

823. Scully, 1993 825. Rainer, 1994/95 826. Haubensak, 1995

830. Bleckner, 1994 831. Stella, 1994 832. De Maria, 1996 833. Rae, 1997

837. Kahukiwa, 1993 838. Hasenböhler, 1993 840. Hume, 1997

1980–2000. The End of Modernism
The Realistic Development

The products of realistic art during the last two decades display a confusing pluralism, even more so than with the other three attitudes.

The first row collects three-dimensional works (figs. 841–844) that with a few exceptions repeat ad absurdum the concept of the readymade – the technique of appropriation.

The second row shows a few old masters of Pop Art and Nouveau Réalisme (figs. 846, 848, 849, 871, 874), the German realists Trockel and Polke (figs. 868, 869) and more recent works in photography (figs. 870, 872).

The third row shows works by the graffiti artists Haring and Basquiat (figs. 851–853) and related endeavors to imitate the naive style of children's drawings (figs. 855, 881). It concludes with examples of Pop Art from Russia, Africa and China that in their essence display a clearly Western inspiration (figs. 876, 877, 879).

The fourth row documents examples of "classical" photo-realism (figs. 859, 860) and the realistic variant of the new, postmodern figuration, as exemplified in artists such as Freud (fig. 856), who proceeds stylistically from Spencer and the realism of the 1930s (see fig. 413 on p. 82). We also see the awkwardly naturalistic pictures of Fischl (figs. 857, 883), the dramatic motion in the group portraits based on the photographic models of Longo (fig. 858), and the schematic portraits and landscapes of Alex Katz (figs. 882, 886). The only fundamentally new approach is seen in Tuymans (fig. 884).

realistic

841. Torres, 1982/83

realistic

846. Lichtenstein, 1981

realistic

851. Haring, 1981

realistic

856. Freud, 1980

842. Haring, 1983

843. Fischli/Weiss, 1984/85

844. Balkenhol, 1985

845. Koons, 1988

848. Warhol, 1985

849. Warhol, 1985

852. Basquiat, 1982

853. Haring, 1984

854. Schnabel, 1986

855. Baechler, 1987/88

857. Fischl, 1982

858. Longo, 1982

859. Cottingham, 1984

860. Gertsch, 1986

realistic ▶

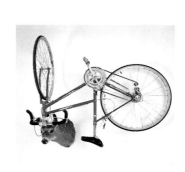

861. Armleder, 1988

862. Mach, 1989

realistic ▶

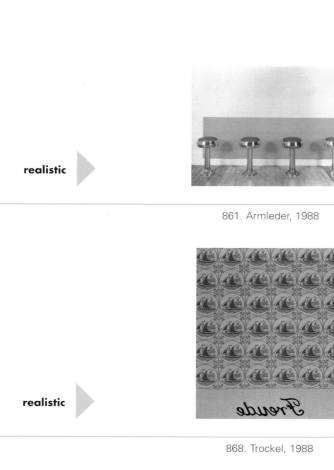

868. Trockel, 1988

869. Polke, 1989

870. Ruff, 1989

realistic ▶

875. Haring, 1988

876. Bulatow, 1988

877. Samba, 1990

realistic ▶

882. Katz, 1987

883. Fischl, 1989

884. Tuymans, 1990

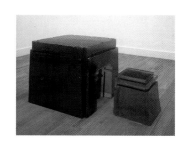
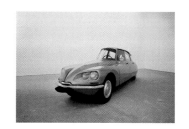
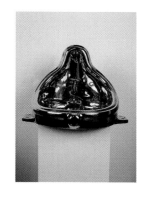

864. Paik, 1989 865. Orozco, 1993 866. Whiteread, 1994 867. Levine, 1996

871. Lichtenstein, 1991 872. Wall, 1993 873. Christo & Jeanne-Claude, 1995 874. Kitaj, 1997

878. Scharf, 1992 879. Guangyi, 1993 881. Baechler, 1996

885. Pearlstein, 1991 886. Katz, 1993 887. Kippenberger, 1994 888. Dumas, 1997

1980–2000. The End of Modernism
The Structural Development

The first three rows display variations, modifications and quotes of the main directions until now in geometric non-figuration – Concrete Art, Op Art, Hard Edge and shaped canvas – in which the pictorial legacy of structural art is treated in various ways.

The veterans and "party line" exponents of these currents (figs. 889–891, 914, 916, 917) remain true to the previous supraliminal set of values and the motto first proclaimed by Leon Battista Alberti, the great architect of the Renaissance: "*Beauty is the revelation of law.*" It is this the claim to universal validity that is ironically questioned by the postmodern artists of the structural tendency (figs. 892, 895, 896, 898, 900, 901, 902, 922, 923).

The fourth row depicts mostly three-dimensional works. Here as well, we see "classical" works of Minimal Art and related currents (figs. 907, 908, 931, 933, 934) alongside postmodernist articulations (figs. 905, 930, 936) that clearly stand out from the former in their arbitrariness.

structural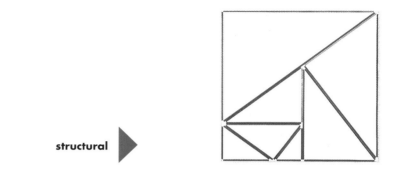

889. Bill, 1980–1982

structural

894. Held, 1980

structural

899. Kelly, 1982

structural

904. LeWitt, 1983

890. Mohr, 1980–1982 891. Lohse, 1983 892. Heilmann, 1985

895. Camesi, 1983 896. Bleckner, 1986 898. Armleder, 1986

900. Armleder, 1983 901. Taaffe, 1985 902. Rockenschaub, 1984 903. Pfahler, 1987

905. Burton, 1983 907. Rückriem, 1986 908. Flavin, 1986

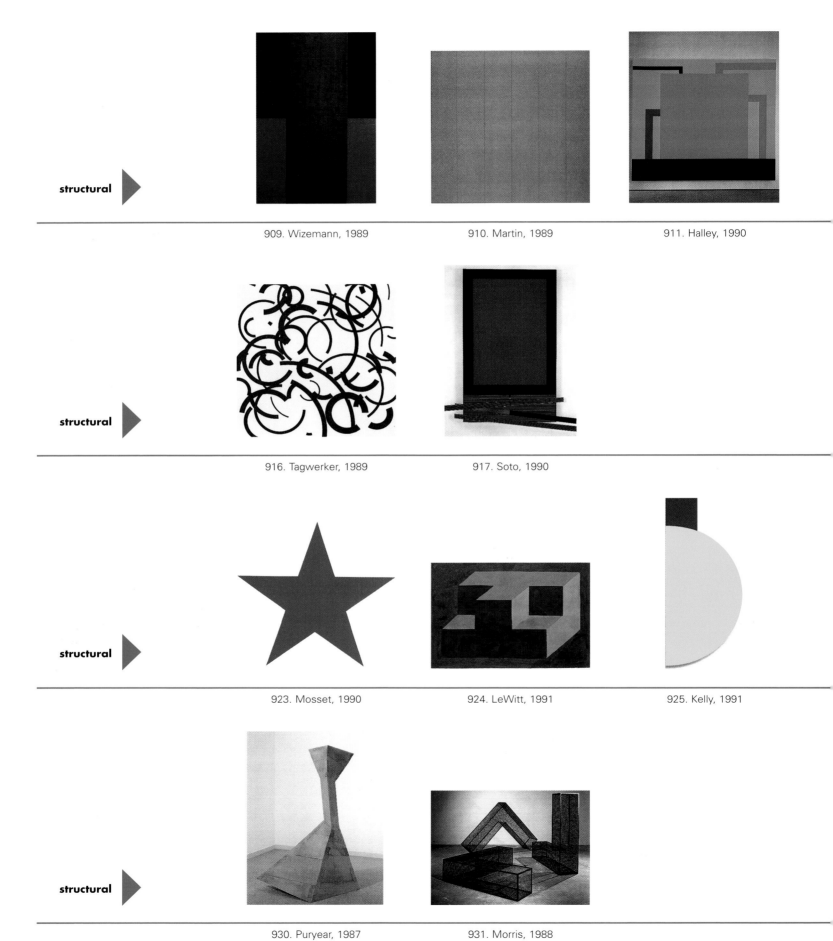

structural

909. Wizemann, 1989 910. Martin, 1989 911. Halley, 1990

structural

916. Tagwerker, 1989 917. Soto, 1990

structural

923. Mosset, 1990 924. LeWitt, 1991 925. Kelly, 1991

structural

930. Puryear, 1987 931. Morris, 1988

913. Locher, 1995

914. Gerstner, 1995

915. Halley, 1997

919. Held, 1990

920. Bleckner, 1993

921. Baudevin, 1994

922. Manz, 1996

926. Honegger, 1992

927. Von Mutzenbecher, 1993

929. Mangold, 1997

933. Morris, 1991

934. LeWitt, 1992

935. Hatoum, 1996

936. Zoderer, 1996

1980–2000. The End of Modernism
The Symbolist Development

In the symbolist tendencies, with which we conclude our survey, we see the most innovative and pathbreaking works of the last developmental phase in Modernism.

The first two rows document the continuation of a figurative symbolism that uses fragmented human figures as its main mode of conveying meaning.
Next to the late, symbolist works of great pioneers like Jasper Johns or Richard Hamilton (figs. 938, 939, 940, 959, 960, 961) and those of the Italian Transavanguardia (figs. 942, 944, 945, 964, 967) this eclectic production also includes postmodernist reversions to the neo-Classicism of the 19th century (figs. 966, 968) and the spectacular manifestations of Young Britart (fig. 970).

The third row documents the creative extension of Arte Povera and related tendencies. The works shown here range from the wall designs of Richard Long (figs. 948, 949) and the objects of Twombly and Buthe to the big installations by Merz and Kounellis.

The fourth row shows the creative use of the new media (photos, video, computer manipulation, installations, performances and environments), with which symbolist art enters new artistic terrain even as Modernism comes to its end. Cindy Sherman creates a new form of self-portraiture with photographic impersonations of fictional destinies (fig. 952). The electronic text panels of Jenny Holzer open new horizons for the visual arts in public spaces (figs. 954, 979). And Nauman's kinetic neon sculptures and video installations bear witness to his continuing originality and unbroken inventiveness (figs. 956, 981).

symbolist ▶

937. Borofsky, 1980

symbolist ▶

942. Chia, 1980

symbolist ▶

947. Zorio, 1981

symbolist ▶

952. Sherman, 1981

938. Johns, 1981 939. Johns, 1982 940. Hamilton, 1982/83 941. Longo, 1986

943. Kiefer, 1981 944. Cucchi, 1983 945. Clemente, 1983 946. Salle, 1986

948. Long, 1982 949. Long, 1984 950. Penone, 1985 951. Twombly, 1986

954. Holzer, 1983–1985 956. Nauman, 1985

1980–2000. The End of Modernism
The Symbolist Development

 symbolist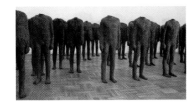

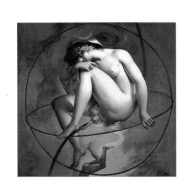

957. Abakanovicz, 1986/87

959. Hamilton, 1988–1990

symbolist

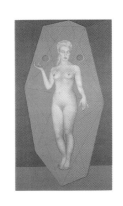

964. Paladino, 1986

965. Lüthi, 1987

966. Mariani, 1989

symbolist

971. Buthe, 1985

972. Fabro, 1986

973. Merz, 1986

 symbolist

978. Boltanski, 1986

979. Holzer, 1987

980. Moffatt, 1989

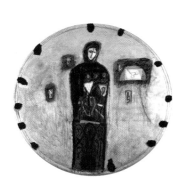

960. Johns, 1990

961. Johns, 1992

963. Salle, 1998

967. Clemente, 1990

968. d'Arcevia, 1992

969. Fritsch, 1993/94

970. Mueck, 1997

974. Kounellis, 1990

975. Acconci, 1990

977. West, 1998

981. Nauman, 1991

982. Horn, 1991

983. Viola, 1996

984. Rist, 1997

Magdalena Abakanovicz 1930
Vito Acconci 1940
Bruno d'Arcevia 1946
John M. Armleder 1948
Frank Auerbach 1931
Donald Baechler 1956
Stephan Balkenhol 1957
Georg Baselitz 1938
Jean-Michel Basquiat 1960–1988
Francis Baudevin 1964
Max Bill 1908–1994
Ross Bleckner 1949
Christian Boltanski 1944
Jonathan Borofsky 1942
Erik Bulatow 1933
Scott Burton 1939
Michael Buthe 1944–1994
Gianfredo Camesi 1940
Sandro Chia 1946
Christo (Christo Javacheff) & Jeanne-Claude (Jeanne-Claude de Guillebon) 1935
Francesco Clemente 1952
Robert Cottingham 1935
Enzo Cucchi 1950
Martin Disler 1949–1996
Marlene Dumas 1953
Luciano Fabro 1936
Helmut Federle 1944
Rainer Fetting 1949
Eric Fischl 1948
Peter Fischli 1952
Dan Flavin 1933–1996
Günther Förg 1952
Lucian Freud 1922
Katharina Fritsch 1956
Karl Gerstner 1930
Franz Gertsch 1930
Raimund Girke 1930
Joseph Glasco 1925
Wang Guangyi 1953
Peter Halley 1953
Richard Hamilton 1922
Keith Haring 1958–1990
Niklaus Hasenböhler 1937–1994
Mona Hatoum 1952
Pierre Haubensak 1935
Mary Heilmann 1940
Al Held 1928
Howard Hodgkin 1932
K.H. Hödicke 1938
Jenny Holzer 1950
Gottfried Honegger 1917
Rebecca Horn 1944
Gary Hume 1962
Jasper Johns 1930
Robyn Kahukiwa 1940

Alex Katz 1927
Ellsworth Kelly 1923
Anselm Kiefer 1945
Martin Kippenberger 1953–1997
Per Kirkeby 1938
Ronald B. Kitaj 1932
Jeff Koons 1955
Jannis Kounellis 1936
Jonathan Lasker 1948
Sherrie Levine 1947
Sol LeWitt 1928
Roy Lichtenstein 1923–1997
Thomas Locher 1956
Richard Paul Lohse 1902–1988
Richard Long 1945
Robert Longo 1953
Urs Lüthi 1947
David Mach 1956
Robert Mangold 1937
Jean-Luc Manz 1952
Brice Marden 1937
Nicola de Maria 1954
Carlo Maria Mariani 1931
Agnes Martin 1912
Mario Merz 1925
Helmut Middendorf 1953
Tracey Moffatt 1960
Manfred Mohr 1938
Robert Morris 1931
Ed Moses 1926
Olivier Mosset 1944
Ron Mueck 1958
Werner von Mutzenbecher 1937
Robert Natkin 1930
Bruce Nauman 1941
Kenneth Noland 1924
Albert Oehlen 1954
Gabriel Orozco 1962
Nam June Paik 1932
Mimmo Paladino 1948
Philip Pearlstein 1924
Giuseppe Penone 1947
Georg Karl Pfahler 1926
Sigmar Polke 1942
Martin Puryear 1941
Fiona Rae 1963
Arnulf Rainer 1929
Gerhard Richter 1932
Pipilotti Rist 1962
Gerwald Rockenschaub 1952
Ulrich Rückriem 1938
Thomas Ruff 1958
Robert Ryman 1930
David Salle 1952
Chéri Samba 1956
Marcel Schaffner 1931

Kenny Scharf 1958
Julian Schnabel 1951
Sean Scully 1945
Cindy Sherman 1954
Jesús Rafael Soto 1923
Matias Spescha 1925
Frank Stella 1936
Philip Taaffe 1955
Bernard Tagwerker 1942
Rigoberto Torres 1960
Rosemarie Trockel 1952
Luc Tuymans 1958
Cy Twombly 1929
Bill Viola 1951
Jeff Wall 1946
Andy Warhol 1928–1987
David Weiss 1946
Franz West 1947
Rachel Whiteread 1963
Yvonne Wilen 1933
Terry Winters 1949
Günther Wizemann 1953
Jerry Zeniuk 1945
Beat Zoderer 1955
Gilberto Zorio 1944

Appendix

Index of Illustrations

Index of Illustrations

159

Bibliography

The date given after the author's name or the catalogue is the date of the first edition.

Ades, Dawn, 1978, Dada and Surrealism Reviews, Arts Council of Great Britain, 1978

Adhemar, Jean and **Cachin, Françoise,** 1972, *Degas: Gravures et Monotypes, Arts et Métiers Graphiques,* Paris, 1972

Adriani, Götz, 1982, *Cézanne, Aquarelle 1866–1906,* exh. cat. Kunsthalle Tübingen, Cologne, 1982

–, 1993, *Cézanne. Gemälde,* exh. cat. Kunsthalle Tübingen, Cologne, 1993

Alloway, Lawrence, 1962, "Pop Art since 1949", in: The Listener, 27. Dec. 1962

–, 1983, *Lichtenstein,* Munich/Lucerne, 1984 (1983)

Alviani, Giulio, 1988, *Josef Albers,* Milan, 1988

American Painting: 1900–1970, 1973, Time-Life Int. 1973

Antonowna, Irina and **Merkert, Jörn** (eds.), 1995, *Berlin-Moskau, Moskau-Berlin 1900–1950,* Munich/New York, 1995

1950–1960 Appel, Dubuffet, Jorn, Michaux, Schumacher, Tapies, Wols, 1983, Bremen, 1983

Armstrong, Richard, 1991, *Al Held,* New York, 1991

Armstrong, Richard; Hanhardt, John G. et al., 1991, *1991 Biennial Exhibition,* Whitney Museum of American Art, New York, 1991

The Art of Assemblage, 1961, exh.-cat. Museum of Modern Art, New York, 1961

Arte abstracto. Arto concreto, Paris cercle et carré, 1930, 1990, Paterna, 1990

Arte Povera, Antiform, 1982, exh. cat. Centre d'Arts Plastiques contemporains de Bordeaux, 1982

Artstudio (ed.), 1987, *La Trans-avant-garde italienne,* Paris, 1987

–, 1989, *Regards sur l'Arte Povera,* Paris, 1989

Barrette, Bill, 1989, *Eva Hesse. Sculpture Catalogue raisonné,* New York, 1989

Bastian, Heiner (ed.), 1988, *Joseph Beuys,* exh. cat. Berlinische Galerie, Martin-Gropius-Bau Berlin, Munich, 1988

Baumgart, Fritz, 1974, *Vom Klassizismus zur Romantik 1750–1832. Die Malerei im Jahrhundert der Aufklärung, Revolution und Restauration,* Cologne, 1974

Bazin, Germain, 1958, *Der Louvre,* Munich/Zurich, 1958

Beuys, Joseph, 1969, exh. cat. Kunstmuseum Basel, 1969

Beye, Peter and **Honisch, Dieter,**1987, *Giacometti Alberto. Skulpturen – Gemälde – Zeichnungen – Graphik,* exh. cat. Nationalgalerie, Staatliche Museen Preußischer Kulturbesitz, Berlin, 1988, Munich, 1987

Bihalji-Merin, Oto and **Seidel, Max,** 1985, *Goya. Glanz und Macht. Die Schrecken des Krieges. Gemälde. Portraits. Radierungen,* Stuttgart/Zurich, 1985

Bild-Lexikon der Kunst, 1976, Cologne, 1976

Billeter, Erika, 1980, *Softart,* Bern, 1980

–, 1980, *Leben mit Zeitgenossen. Die Sammlung der Emanuel-Hoffmann-Stiftung,* Basel, 1980

Der blaue Reiter, 1986, exh. cat. Kunstmuseum Bern, Bern, 1986

Bleckner, Ross. New Paintings, 1989, exh. cat. Akira Ikeda Gallery, Tokyo, 1989

Bocola, Sandro, 1994, *Die Kunst der Moderne. Zur Struktur und Dynamik ihrer Entwicklung. Von Goya bis Beuys,* Munich/New York, 1994

–, 1999, *The Art of Modernism. Art Culture and Society from Goya to the Present Day.* Translated by Catherine Schelbert and Nicholas Levis. Munich/London/New York, 1999

–, 1999, *El arte de la modernidad. Estructura y dinamica de su evolucion de Goya a Beuys.* Traducción de Rosa Sala. Barcelone, 1999

Boltanski, Buren, Gilbert & George, Kounellis, LeWitt, Long, Merz, 1990, exh. cat. 1990

Bousquet, Jacques, 1963, *Malerei des Manierismus,* Munich, 1985 (1963)

Braun, Emily (ed.), 1989, *Italian Art in the 20th Century,* New York, 1989

Brown, David B. and **Schröder, Klaus Albrecht** (eds.), 1997, *Joseph Mallord William Turner,* Munich/New York, 1997

Bruderer, Hans Jürgen and **Fath, Manfred,** 1995, *Neue Sachlichkeit. Bilder auf der Suche nach der Wirklichkeit. Figurative Malerei der zwanziger Jahre,* Munich/New York, 1995

Budde, Rainer (ed.), 1997, *Pointillismus. Auf den Spuren von Georges Seurat,* Munich/New York, 1997

Bürgi, Bernhard, 1988, *Rot, Gelb, Blau. Die Primärfarben in der Kunst des 20. Jahrhunderts,* Stuttgart/Teufen, 1988

Buthe, Michael, 1999, *Michel de la Sainte Bauté,* exh. cat. Kunstmuseum Düsseldorf 1999, Heidelberg/Düsseldorf, 1999

Cassou, Jean, *Symbolismus,* Cologne w.y.

Cézanne, the Late Work, 1977, exh. cat. Museum of Modern Art, New York, 1977

Chagall, Marc. Les années russes, 1907–1922, 1995, Paris-Musées, Paris, 1995

Chagall, Kandinsky, Malewitsch und die russische Avantgarde, 1998, exh. cat. Hamburger Kunsthalle, Kunsthaus Zürich, Ostfildern-Ruit, 1998

Christo, 1977, *The Running Fence,* Stuttgart, 1977

Chronik der Menschheit, 1997, Augsburg, 1997

Clearwater, Bonnie, 1984, *Mark Rothko: Works on Paper,* New York, 1984

Clemente, Francesco, 1987, exh. cat. Öffentliche Kunstsammlung Basel, 1987

Colección Panza, 1988, exh. cat. Centro de arte Reina Sofia, Madrid, 1988

Cooper, Douglas and **Tinterow, Gary,** 1983, *The Essential Cubism. Braque, Picasso and their friends 1907–1920,* Tate Gallery, London, 1983

Copland, J., 1967, "Roy Lichtenstein", in *Roy Lichtenstein,* exh. cat. Pasadena Art Museum, 1967

Cornell, Joseph/Marcel Duchamp … in resonance, 1998, exh. cat. Menil Foundation Inc., Houston, 1998

Cowart, Jack and **Fourcade, Dominique,** 1987, *Henri Matisse. The Early Years in Nice 1916–1930,* exh. cat. National Gallery of Art, Washington, New York, 1987

Craig, Gordon A., 1974, *Europe since 1815,* New York, 1974

Crichton, Michael, 1977, *Jasper Johns,* London, 1977

Cucchi, Enzo, La Disegna, 1988, exh. cat. Kunsthaus Zürich, 1988

Dada and Surrealism reviewed, 1987, exh. cat. Hayward Gallery, London, 1987

Decrouet, Christian and **Boissel, Jessica,** 1984, *Kandinsky. Œuvres de Vassily Kandinsky,* Musée national d'Art moderne, Centre Georges Pompidou, Paris, 1984

Degas, Edgar, 1988, exh. cat. Galerie Nationale du Grand Palais, Paris, 1988

Delacroix, Eugène, 1987, exh. cat. Kunsthaus Zürich and Städtische Galerie im Städelschen Kunstinstitut, Frankfurt a. M., 1987

Delevoy, Robert L., 1982, *Le Symbolisme,* Geneva, 1982

Denis, Valentin, 1980, *Van Eyck,* Paris, 1980

Diehl, Gaston, 1985, *Fernand Léger,* Munich, 1985

Disler, Martin. Zeichnungen 1968–1983 und das große Bild »Öffnung eines Massengrabs« von 1982, 1983, exh. cat. Kunstmuseum Basel, Basel, 1983

The Drawings of Henri Matisse, 1985, exh. cat. Museum of Modern Art, New York, 1985

Droste, Magdalena, 1991, *bauhaus 1919–1933,* Cologne, 1991

du. Die Zeitschrift der Kultur, 1983, 1989, Zurich, 1983, 1989

du. Kulturelle Monatszeitschrift, 1960, 1962, Zurich, 1960, 1962

Duchamp, Marcel, 1965, exh. cat. Kestner-Gesellschaft, Hanover, 1965

Duchamp, 1984, exh. cat. Caja de Pensiones, Madrid, 1984

Düchting, Hajo, 1997, *Manet – Pariser Leben,* Munich/New York, 1997

Eggum, Arne, 1984, *Edvard Munch. Gemälde, Zeichnungen und Studien,* Stuttgart, 1986 (1984)

Elderfield, John, 1978, *The Cut-Outs of Henri Matisse,* London, 1978

–, 1992, *Henri Matisse. A Retrospective,* exh. cat. Museum of Modern Art, New York, 1992

Ensor, James, 1983, exh. cat. Kunsthaus Zürich, 1983

Erben, Walter, 1989, *Miró,* Cologne, 1989

The Essential Cubism 1907–1920, 1983, exh. cat. Tate Gallery, London, 1983

Faust, Wolfgang Max and **de Vries, Gerd,** 1982, *Hunger nach Bildern. Deutsche Malerei der Gegenwart,* Cologne, 1982

Fondation Beyeler, 1997, Munich/New York, 1997

Foucart, Bruno, 1977, *G. Courbet,* Naefels, 1977

Frèches-Thory, Claire and **Perucchi-Petri, Ursula** (eds.), 1998, *Die Nabis. Propheten der Moderne,* Munich/New York, 1998

Futurismo & Futurismi, 1986, exh. cat. Palazzo Grassi Venice, Milan, 1986

Gage, John, 1974, »Realism«, in: *A Visual Dictionary of Art,* ed. by Ann Hill, London, 1974

Gasquet, Joachim, 1921, *Cézanne,* Paris, 1921

Gassen, Richard W. (ed.), 1998, *Kunst im Aufbruch. Abstraktion zwischen 1945 und 1959,* Ostfildern-Ruit, 1998

Gassier, Pierre, 1973, *Francisco Goya: Die Skizzenbücher,* Frankfurt a. M./Berlin/Vienna, 1973

Gassier, Pierre and **Wilson, Juliet,** 1971, *Goya, His Life and Work,* London, 1971

Gauguin, Paul, 1987, exh. cat. Musée départemental du Prieuré, Saint-Germain-en-Laye (Yvelines), 1987

Geelhaar, Christian, 1982, *Paul Klee, Life and Work,* New York, 1982

–, 1992, *Kunstmuseum Basel. Die Geschichte der Gemäldesammlung und eine Auswahl von 250 Meisterwerken,* Verein der Freunde des Kunstmuseum Basel und Eidolon AG, Zurich/Basel, 1992

Giacometti, Alberto, 1963, exh. cat. Galerie Beyeler, Basel, 1963

Giacometti, Alberto, 1989, exh. cat. Galerie Beyeler, Basel, 1989

Glozer, Laszlo (ed.), 1981, *Westkunst: Zeitgenössische Kunst seit 1939,* Guide to the international exhibition in the Rheinhallen at Cologne Fair, by Marcel Baumgartner et al., Cologne, 1981

Goldman, Judith, 1994, *The Pop Image. Prints and Multiples,* New York, 1994

Gowing, Laurence, 1988, *Die Gemäldesammlung des Louvre,* Cologne, 1988

La grande parade. Highlights in Painting after 1940, Hoogtepunten van de schilderkunst na 1940, w.y. Meulenhoff/Landshoff, Amsterdam, Munich

Gray, Camilla, 1986, *The Russian Experiment in Art,* London, 1986

Grosenick, Uta and **Riemschneider, Burkhard** (eds.), 1999, *Art at the turn of the Millennium,* Cologne, 1999

Güse, Ernst-Gerhard, 1982, *Die Tunisreise. Klee – Macke – Moilliet,* Stuttgart, 1982

–, (ed.), 1990, *Paul Klee. Wachstum regt sich. Klees Zwiegespräche mit der Natur,* Munich, 1992 (1990)

Guston, Philip: Paintings, 1969–80, 1982, exh. cat. The Whitechapel Art Gallery, London, 1982

Haffner, Sebastian, 1987, *Im Schatten der Geschichte,* Munich, 1987

Hamilton, Richard, 1964, exh. cat. Hanover Gallery, London, 1964

–, 1970, exh. cat. Tate Gallery, London, and Kunsthalle Bern, 1970

–, 1992, exh. cat. Tate Gallery, London, 1992

Der Hang zum Gesamtkunstwerk. Europäische Utopien seit 1800, 1983, exh. cat. Zurich, Aarau, 1983

Bibliography

Harnoncourt, d'Anne and **Mc Shine, Kynaston**, 1973, *Marcel Duchamp*, The Museum of Modern Art, New York, Munich, 1989 (1973)

Hasenböhler-Dill, Doris; Hasenböhler, Serge and **Wittwer, Hans Peter** (eds.), 1997, *Niklaus Hasenböhler 1937–1994, Das Gesamtwerk*, Basel, 1997

Haubensak, Pierre, 1983, exh. cat. Bündner Kunstmuseum, Chur, 1983

–, 1990, *Bilder 1985–1989*, exh. cat. Kunstmuseum Winterthur, Winterthur, 1990

–, 1996, exh. cat. Helmhaus Zürich, 1996

Heller, Reinhold, 1997, *Toulouse-Lautrec: The Soul of Montmartre*, New York, 1997

Herbert, Robert L., 1988, *Impressionism*, Yale, 1988

Hess, Walter (ed.), 1956, *Dokumente zum Verständnis der Modernen Malerei*, Reinbek bei Hamburg, 1988 (1956)

Höfliger-Griesser, Yvonne et al., 1983, *Gruppe 33. Die Geschichte der "Gruppe 33" zum 50jährigen Bestehen einer Basler Künstlervereinigung*, Editions Galerie "zem Specht", Basel, 1983

Hofstätter, Hans H., 1965, *Symbolismus und die Kunst der Jahrhundertwende*, Cologne, 1965

Honnef, Klaus, 1988, *Contemporary Art*, Cologne, 1988

Hoog, Michael, 1987, *Gauguin; Leben und Werk*, Munich, 1987

Hopps, Walter, 1991, *Robert Rauschenberg, The Early 1950s*, Menil Foundation Inc. Branard, 1991

Hopps, Walter and **Davidson, Susan**, 1998, *Robert Rauschenberg. Retrospektive*, New York and Ostfildern-Ruit, 1998

Hughes, Robert, 1980, *The Shock of the New. Art and the Century of Change*, London, 1991 (1980)

Hüttinger, Eduard (ed.), 1987, *Max Bill*, Zurich, 1987

Huyghe, René, 1995, *Gauguin*, London, 1995

The Image of Abstraction, 1988, exh. cat. The Museum of Contemporary Art, Los Angeles, 1988

Jencks, Charles A., 1987, *Post-Modernism. The New Classicism in Art and Architecture*, London, 1987

Joachimides, Christos M. and **Rosenthal, Norman** (eds.), 1986. *Deutsche Kunst im 20. Jahrhundert. Malerei und Plastik 1905–1985*, Munich, 1986

–, 1993, *American Art in the 20th Century*, New York, 1993

–, 1997, *Die Epoche der Moderne. Kunst im 20. Jahrhundert*, Ostfildern-Ruit, 1997

Joray, Marcel (ed.), 1965, *Kunst des 20. Jahrhunderts: Vasarely*, Neuchâtel, 1965

Kandinsky und München, 1982, exh. cat. Städtische Galerie im Lenbachhaus, Munich, 1982

Kandinsky, Wassily, 1984, exh. cat. Musée national d'Art moderne, Centre Georges Pompidou, Paris, 1984

Kandinsky, Wassily and **Marc, Franz** (eds.), 1912, *Der blaue Reiter*, Munich, 1987 (1912)

Karo Dame. Konstruktive, Konkrete und Radikale Kunst von Frauen von 1914 bis heute, 1995, exh. cat., Aargauer Kunsthaus, Aarau, 1995

Katz, Alex, 1996, exh. cat. Instituto Valenciano de Arte Moderno, Valencia, 1996

Kellein, Thomas, 1998, *Caspar David Friedrich. Der künstlerische Weg*, Munich/New York, 1998

Kingsley, April, 1992, *The Turning Point. The Abstract Expressionists and The Transformation of American Art*, New York/London/Toronto, 1992

Kirkeby, Per. Werke 1983–1988, 1989, exh. cat. Kunstmuseum Winterthur, Winterthur, 1989

Klee, Paul, 1964, *The Diaries of Paul Klee 1898–1918*, Berkeley, 1964

Klee, Paul, Leben und Werk, 1987, Paul Klee-Stiftung (ed.), exh. cat. Kunstmuseum Bern, Teufen, 1987

Klein, Yves, 1973, exh. cat. Gimpel & Hanover Galerie, Zurich, 1973

Kleiner, Marion; Kurtz, Thomas and **Nadin, Mihai**, 1994, *Manfred Mohr*, Zurich, 1994

Klemm, Christian, 1992, *Kunsthaus Zürich*, Zurich, 1992

Koella, Rudolf, 1975, *Collection Oskar Reinhart*, Neuchâtel, 1975

Koja, Stephan, 1996, *Claude Monet*, Munich/New York, 1996

Konstruktivistische Internationale. Schöpferische Arbeitsgemeinschaft 1922–1927. Utopien für eine europäische Kultur, 1992, Kunstsammlung Nordrhein-Westfalen, Düsseldorf/Stuttgart, 1992

Kosinski, Dorothy (ed.), 1994, *Fernand Léger 1911–1924. Der Rhythmus des modernen Lebens*, Munich/New York, 1994

Kounellis, Jannis, 1979, exh. cat. Pinacoteca provinciale di Bari, Rome, 1979

Kounellis, Jannis, 1986, exh. cat. Museum of Contemporary Art, Chicago, 1986

Kozloff, Max, 1969, *Jasper Johns*, New York, 1969

Kunstforum International. Die aktuelle Zeitschrift für alle Bereiche der Bildenden Kunst, 1992, 1997, Ruppichteroth, 1992, 1997

Kunstverein Hamburg (ed.), 1968, *Katalog zur Sammlung Karl Ströher*, 1968

Lanchner, Carolyn, 1993, *Joan Miró*, New York, 1993

Lebel, Robert; Sanouillet, Michel and **Waldberg, Patrick**, 1987, *Surrealismus*, Cologne, 1987

Lemaire, Gérard-Georges, 1997, *Soto*, Paris, 1997

Lemoine, Serge, 1986, *François Morellet*, Zurich, 1986

LeWitt, Sol. Drawings 1958–1992, 1992, exh. cat. Haags Gemeentemuseum, The Hague, 1992

Leymarie, Jean, 1959, *Le Fauvisme*, Geneva, 1987 (1959)

–, (ed.), 1988, *Georges Braque*, Munich, 1988

Livingstone, Marco, 1979, *Allen Jones. Sheer Magic*, London, 1979

–, (ed.), 1992, *Pop Art*, Munich, 1992

–, 1998, *R. B. Kitaj. An American in Europe*, Sprengel Museum Hannover, Hanover, 1998

Lohse, Richard Paul, Modulare und serielle Ordnungen, 1975, exh. cat. Städtische Kunsthalle Düsseldorf, 1975

Lohse, Richard Paul, 1984, *Modulare und serielle Ordnungen*, Zurich, 1984

Lucie-Smith, Edward, 1969, *Movements in Art since 1945*, London, 1984 (1969)

–, 1997, *Kunst heute. Art today*, Munich, 1997

Magritte, René. Die Kunst der Konversation, 1996, Munich/New York, 1996

Malevich, Kasimir, 1927, *Non Objective World*, 1927

Mangold, Robert. Gemälde, 1980, exh. cat. Kunsthalle Bielefeld, Bielefeld, 1980

Mangold, Robert. Zone Paintings, 1997, exh. cat. Pace Wildenstein, 1997

Marden, Brice, 1996, exh. cat. Matthew Marks Gallery, New York, 1996

Matisse, 1982, exh. cat. Kunsthaus Zürich, Bern, 1982

Maur, Karin v. (ed.), 1985, *The Sound of Painting. Music in Modern Art*, New York, 1999

McShine, Kynaston, 1980, *Joseph Cornell*, Munich, 1990 (1980)

–, (ed.), 1989, *Andy Warhol, A Retrospective*, exh. cat. Museum of Modern Art, New York, Boston, 1989

Meadows, Dennis, 1972, *The Limits to Growth*, 1972

Merz, Mario, exh. cat. Galleria Pieroni, Rome, 1985

Merz, Mario, exh. cat. Kunsthaus Zürich, 1985

Messer, Thomas M., 1996, *Lucio Fontana. Retrospektive*, Ostfildern-Ruit, 1996

Milner, John, 1988, *The Studios of Paris. The Capital of Art in the Late Nineteenth Century*, New Haven/London, 1988

Moffet, Charles J., 1986, *The New Painting: Impressionism 1874–1886*, Oxford, 1986

Moffett, Kenworth, 1981, *Jules Olitski*, New York, 1981

Mondrian, 1985, exh. cat. Haags Gemeentemuseum, The Hague, 1985

Mondrian, 1987, exh. cat. Seibu Museum of Art, Tokyo, 1987

Mondrian. From Figuration to Abstraction, 1988, exh. cat., London, 1988

Monet, Claude, Nympheas, 1986, exh. cat. Kunstmuseum Basel, Zurich, 1986

Monet in London, 1988, exh. cat. High Museum of Art, Atlanta, Georgia, Seattle/London, 1988

Morandi, Giorgio, 1973, exh. cat. Galleria nazionale d'arte moderna, Rome, 1973

Moreau, Gustave, 1986, exh. cat. Kunsthaus Zürich, Zurich, 1986

Mössinger, Ingrid (ed.), 1995, *Sam Francis. The Shadow of Colors*, Kilchberg/Zurich, 1995

Murphy, Richard W., 1968, *The World of Cézanne, 1839–1906*, Time-Life Int., 1968

Das Musée d'Orsay, 1987, Stuttgart, 1987

The Museum of Modern Art, New York, The History and the Collection, 1985, New York, 1985

von Mutzenbecher, Werner, 1993, exh. cat., Basel, 1993

Nakov, Andrei, 1984, *Russische Avantgarde*, Geneva, 1984

Namuth, Hans, 1978, *L'atelier de Jackson Pollock*, Paris, 1978

Nash, Steven A. and **Merkert, Jörn**, 1986, *Naum Gabo; mit dem Œuvre-Katalog der Konstruktionen und Skulpturen. Sechzig Jahre Konstruktivismus*, Munich, 1986

Nauman, Bruce, 1973, exh. cat. Kunsthalle Bern, 1973

Nauman, Bruce, 1994, exh. cat. Walker Art Center, Minneapolis, 1994

noëma art journal, 1999, No. 50. Jan.–Mar. '99, Vienna, 1999

Noever, Peter (ed.), 1991, *Aleksandr M. Rodchenko, Varvara F. Stepanova. The Future Is Our Only Goal*, Munich, 1991

Les Nouveaux Réalistes, 1986, exh. cat. Musée d'Art Moderne de la Ville de Paris, 1986

Novotny, Fritz, 1995, *Die großen Impressionisten*, Munich/New York, 1995

O'Hara, Frank, 1965, *Robert Motherwell with Selections from the Artist's Writing,* The Museum of Modern Art, New York, 1965

Oldenburg, Claes, 1966, exh. cat. Moderna Museet, Stockholm, 1966

–, 1970, exh. cat. Museum of Modern Art, New York, 1970

Oliva, Achille Bonito, 1982, *Transavantgarde*, Milan, 1982

Paintings from the Collection of Mr. and Mrs. Victor W. Ganz, 1988, exh. cat. from 10th November 1988, Sotheby's, New York, 1988

Pérez Sánchez, Alfonso E. and **Gállego, Julián**, 1995, *Goya. The Complete Etchings and Lithographics*, New York, 1995

Picasso. Die Zeit nach Guernica 1937–1973, 1993, Stuttgart, 1993

Picasso-Museum Paris: Die Meisterwerke, 1991, Réunion des Musées Nationaux, Munich, 1991

Pierre, José, 1985, *Introduction à la peinture*, 1985

Polcari, Stephen, 1991, *Abstract Expressionism and the Modern Experience*, Cambridge/New York/Port Chester, 1991

Pollock, Jackson, 1982, exh. cat. Musée national d'Art moderne, Centre Georges Pompidou, Paris, 1982

Raeburn, Michael (ed.), 1994, *Salvador Dalí: The Early Years*, London, 1994

Ramos, Mel. Pop Art Images, 1994, Cologne, 1994

Rauschenberg, Robert: The Early 1950s, 1991, ed. by Walter Hopps, Houston, 1991

Realismus – Zwischen Revolution und Reaktion 1919–1939, 1981, exh. cat. Staatliche Kunsthalle Berlin, Munich, 1981

Reff, Theodore, 1982, *Manet and Modern Paris*, Chicago, 1983 (1982)

Regel und Abweichung, 1997, exh. cat. Haus für kostruktive und konkrete Kunst, Zurich, 1997

Retrovision Peter Phillips. Paintings 1960–1982, 1982, Walker Art Gallery, Liverpool, 1982

Rewald, John, 1946, *History of Impressionism*, New York, 1946

–, 1996, *Paul Cézanne*, New York, 1996

Ritzenthaler, Cécile, 1987, *L'Ecole des Beaux-Arts du XIXᵉ Siècle, Les Pompiers*, Paris, 1987

Roberts-Jones, Philippe, 1978, *La Peinture Irréaliste au XIXᵉ Siècle*, Fribourg, 1978

Roger-Marx, Claude, 1949, *Ingres*, Lausanne, 1949

Rose, Barbara, 1970, *Claes Oldenburg*, exh. cat. Museum of Modern Art, New York, 1970

Rosenblum, Robert and **Janson, H. W.**, 1984, *Art of the Nineteenth Century*, London, 1984

Rotzler, Willi, 1975, *Objektkunst*, Cologne, 1981 (1975)

–, 1977, *Konstruktive Konzepte*, Zurich, 1988 (1977)

Rousseau, Henri, 1985, exh. cat. Museum of Modern Art, New York, 1985

Rubin, William, 1968, *Surrealismus*, Teufen, 1968

–, 1969, *Dada and Surrealist Art*, London, 1969

–, (ed.), 1980, *Pablo Picasso. A Retrospective*, The Museum of Modern Art, New York, Boston, 1980

–, (ed.), 1984, *"Primitivism" in 20th-Century Art, Affinity of the Tribal and the Modern*, New York, 1984

–, 1989, *Picasso and Braque. Pioneering Cubism*, The Museum of Modern Art, New York, 1989

Rublowsky, John, 1965, *Pop Art*, New York, 1965

Russell, John, 1969, *The World of Matisse, 1869–1954*, Time-Life Int., 1969

Russell, John and **Gablik, Suzi**, 1969, *Pop Art Redefined*, New York, 1969

Russian Avant-Garde Art: The George-Costakis Collection, 1981, New York, 1981

Salle, David, 1999, exh. cat. Stedeljik Museum Amsterdam, Ghent/Amsterdam, 1999

San Lazzaro, G. di, 1975, *Hommage to Wassily Kandinski*, New York, 1975

Sandler, Irving, 1984, *Al Held*, New York, 1984

Saura, Antonio. Imagined 1956–1997, 1997, exh. cat. Konsthall Malmö, 1997

Schacherl, Lillian, 1997, *Edgar Degas: Dancers and Nudes*, Munich/New York, 1997

Schaffner, Marcel, 1997, exh. cat. Galerie Carzaniga + Ueker, Basel, 1997

Schmalenbach, Werner, 1967, *Kurt Schwitters*, Munich, 1984 (1967)

–, 1986, *Bilder des 20. Jahrhunderts. Die Kunstsammlung Nordrhein-Westfalen*, Munich, 1986

–, 1988, *African Art from the Barbier-Mueller Collection*, Geneva, Munich, 1988

–, 1990, *Amedeo Modigliani. Paintings, Sculptures, Drawings*, New York, 1990

Schmied, Wieland, 1995, *Edward Hopper: Portraits of America*, Munich/New York, 1995

–, 1996, *Francis Bacon*, Munich, 1996

Schmidt, Georg, 1964, *Kunstmuseum Basel: 150 Gemälde, 12.–20. Jahrhundert*, ed. by Verein Freunde des Kunstmuseum, Basel, 1977 (1964)

–, 1976, *Umgang mit Kunst*, ed. by Verein Freunde des Kunstmuseum, Basel, 1976

Schneider, Pierre, 1968, *Manet und seine Zeit*, Time-Life Int., 1985 (1968)

–, 1984, *Matisse*, Munich, 1984

Schulz-Hoffmann, Carla and **Weiss, Judith C.**, 1984, *Max Beckmann – Retrospektive*, Munich, 1984

Schuster, Peter-Klaus (ed.), 1987, *Nationalsozialismus und "Entartete Kunst"*, Munich, 1987

Schwarz, Arturo, 1974, *La mariée mise à nu chez Marcel Duchamp*, Paris, 1974

Schwitters, Kurt, 1986, exh. cat. Sprengel Museum Hannover, Frankfurt a. M./Berlin, 1986

Seiberling, Grace, 1989, *Monet in London*, exh. cat. High Museum of Art, Atlanta, Giorgia, Seattle/London, 1989

Serra, Richard, 1988, exh. cat. Kunsthalle Basel, 1988

Shadowa, Larissa A., 1982, *Kasimir Malewitsch und sein Kreis: Suche und Experiment. Aus der Geschichte der russischen und sowjetischen Kunst zwischen 1910 und 1930*, Munich, 1982

Shapiro, David, 1984, *Jasper Johns, Drawings 1954–1984*, New York, 1984

Short, Robert, 1980, *Dada und Surrealismus*, Stuttgart/Zurich, 1980

Smith, Kimber. Arbeiten auf Leinwand und Papier von 1952 bis 1981, 1984, Zurich, 1984

Spescha, Matias. Die Druckgraphik 1953–1992, 1993, exh. cat. Bündner Kunstmuseum, Chur, 1993

Spies, Werner, 1975, *Max Ernst – Collagen. Inventar und Widerspruch*, Cologne, 1975

Spoerri, Daniel, 1972, exh. cat. Helmhaus Zürich, Zürcher Kunstgesellschaft, Zurich, 1972

–, 1990, exh. cat. 1990/91, 1990

Stauffer, Serge (ed.), 1983, *Marcel Duchamp: Die Schriften*, Zurich, 1983

Steversen, Rolf, 1949, *Edvard Munch*, Zurich, 1949

Stutzer, Beat and **Koepplin, Dieter**, 1991, *Marcel Schaffner*, Basel, 1991

Tesch, Jürgen and **Hollmann, Eckhard** (eds.), 1997, *Icons of Art. The 20th Century*, New York, 1997

Thürlemann, Felix (ed.), 1986, *Kandinsky über Kandinsky: Der Künstler als Interpret eigener Werke*, Bern, 1986

Tomkins, Calvin, 1966, *Marcel Duchamp und seine Zeit*, Time-Life Int.,1979 (1966)

Traum und Wirklichkeit Wien 1870–1930, 1984, exh. cat. Historisches Museum der Stadt Wien, 1984

Tschopp, Walter, 1985, *Walter Bodmer. Maler und Plastiker 1903–1973*, Basel, 1985

Türr, Karina, 1986, *Op Art. Stil, Ornament oder Experiment?*, Berlin, 1986

Twombly, Cy, Bilder, Arbeiten auf Papier, Skulpturen, 1987, exh. cat. Kunsthaus Zürich, 1987

Varnedoe, Kirk, 1989, *A Fine Disregard. What makes Modern Art Modern*, New York, 1989

–, 1996, *Jasper Johns. A Retrospective*, The Museum of Modern Art, New York, 1996

–, 1999, *Jackson Pollock*, exh. cat. The Museum of Modern Art, New York, 1999

Varnedoe, Kirk and **Gopnik, Adam**, 1990, *High & Low. Modern Art. Popular culture*, Museum of Modern Art, New York, 1990

Vedova 1935–1984. A cura die Germano Celant, 1984, exh. cat. 1984, Milan, 1984

Vigne, G., 1995, *Ingres*, Paris, 1995

Von Ingres bis Cézanne, Kunst des 19. Jahrhunderts aus der Sammlung des Musée du Petit Palais, 1998, exh. cat. Kunst- und Ausstellungshalle der Bundesrepublik Deutschland, Bonn, 1998

Waldberg, Patrick, 1997, *Surrealism*, London, 1997

Waldmann, Diane, 1978, *Mark Rothko*, London, 1978

–, 1996, *Ellsworth Kelly. A Retrospective*, The Solomon R. Guggenheim Foundation, New York,1996

Walther, Ingo F. (ed.), 1998, *Art of the 20th Century*, Cologne, 1998

Warhol, Andy, 1968, exh. cat. Moderna Museet, Stockholm, 1968

Warncke, Carsten-Peter, 1990, *The Ideal as Art – De Stijl 1917–1931*, Cologne, 1990

Weisenberger, Edward (ed.), 1986, *The Spiritual in Art: Abstract Painting 1890–1985*, exh. cat. Los Angeles County Museum of Art, Chicago, 1986

Weiss, Evelyn, 1993, *Russische Avantgarde im 20. Jahrhundert. Von Malewitsch bis Kabakov; die Sammlung Ludwig*, Munich/New York, 1993

Wells, H.G., 1926, *Die Geschichte unserer Welt*, Zurich, 1975 (1926)

–, 1920, *Die Weltgeschichte*, 3 vols., Berlin, 1928 (1920)

Wertenbaker, Lael, 1967, *World of Picasso*, Time-Life Int., 1967

Wijsenbeck, L. J., 1968, *Piet Mondrian*, Recklinghausen, 1968

Wilson-Bareau, Juliet and **Marqués, Manuela B. Mena**, 1994, *Goya. Truth and Fantasy. The Small Paintings*, Museo del Prado, Madrid, 1994

Wols. Bilder, Aquarelle, Zeichnungen, Photographien, Druckgraphik, 1989, exh. cat. Kunsthaus Zürich, 1989

Zeniuk, Jerry. Bilder. Paintings. 1971–1989, 1990, exh. cat. Kunsthalle Bremen, Bremen, 1990

Zilcer, Judith, 1997, *Richard Lindner. Gemälde und Aquarelle 1948–1977*, Munich, 1997

Zurcher, Bernhard, 1985, *Van Gogh: Leben und Werk*, Munich, 1985

Zweite, Armin (ed.), 1982, *Kandinsky und München. Begegnungen und Wandlungen 1896–1914*, Munich, 1982

–, (ed.), 1991, *Der blaue Reiter im Lenbachhaus München*, Munich, 1991

–, 1997, *Barnett Newman. Bilder, Skulpturen, Graphik*, Ostfildern-Rust, 1997

The Author

Sandro Bocola was born in Trieste, Italy, in 1931 and grew up in Libya and Switzerland. After many years in Barcelona and Paris he has been living in Zurich since 1970. He initially worked as a painter, sculptor, exhibition designer and graphic artist. In 1978 he founded the Museo de Arte Popular in Horta de San Juan, Spain. Since 1981 he has been publishing theoretical writings on the social psychology and psychology of art. *Die Erfahrung des Ungewissen in der Kunst* appeared in 1987. In 1994 he was responsible for the concept and artistic direction of the touring exhibition "Afrikanische Sitze" (African Chairs) for the Vitra Design Museum in Weil am Rhein. He was editor of the catalogue of this exhibition. His book *Die Kunst der Moderne. Zur Struktur und Dynamik ihrer Entwicklung. Von Goya bis Beuys* was published in the same year and translated into English *(The Art of Modernism. Art, Culture and Society from Goya to the Present Day)* and Spanish in 1999.

Copyrights

Index of Artists

Index of Artists